THE NAKED MUSE

Kelley Swain was born in Rhode Island, 1985, and is now based in London, working as a writer, editor and educator in poetry, science, and the medical humanities. Her poetry publications include the verse drama *Opera di Cera* (Valley Press, 2014), the collection *Atlantic* (Cinnamon Press, 2014) and her first book, *Darwin's Microscope* (Flambard Press, 2009).

Her debut novel, *Double the Stars*, about astronomer Caroline Herschel, was published by Cinnamon Press in September 2014. She is editor of two anthologies, themed on science and art; *The Rules of Form: Sonnets and Slide Rules* (Whipple Museum, 2012) and *Pocket Horizon* (Valley Press, 2013).

The Naked Muse

KELLEY SWAIN

To my World Muse.
Sorry I could not get the Hardback.
HPX 1/VI/2016

VP

Valley Press

First published in 2016 by Valley Press
Woodend, The Crescent, Scarborough, YO11 2PW
www.valleypressuk.com

First edition, first printing (April 2016)

ISBN 978-1-908853-67-7
Cat. no. VP0084

Copyright © Kelley Swain 2016

The right of Kelley Swain to be identified as the
author of this work has been asserted in accordance with
the Copyright, Designs and Patents Act 1988.

All rights reserved. No part of this publication may be
reproduced, stored in or introduced into a retrieval system,
or transmitted in any form, by any means (electronic,
mechanical, photocopying, recording or otherwise) without
prior written permission from the rights holders.

A CIP record for this book is available from the British Library.

Cover photo: Kelley Swain, © Nicola Pappalettera
Cover and text design by Jamie McGarry

Printed and bound in the EU by Pulsio, Paris.

www.valleypressuk.com/authors/kelleyswain

Supported using public funding by
**ARTS COUNCIL
ENGLAND**
LOTTERY FUNDED

'Nulla dies sine linea'
'Not a day without a line'
Motto of Rococo painter Jan Anton Garemijn

To dear Patricia Hammond:
who understands

Chapter One

The Fingers of the Light
Tapped soft upon the Town
With 'I am great and cannot wait
So therefore let me in.' [a]

IT'S AS IF we're about to kiss, this other girl, and I. But she just keeps looking, deep, into my eyes.

No – at my eyes. Not into.

'Into her personal space,' Bill instructs.

I look past her, out the window, to the white-grey cloud cover of a Flemish sky. It is June. We are in Bruges. I can feel her breath. The vast studio is cool and dark, with windows part-boarded to create a classical light.

'Look at how thick her eyelids are,' Bill says. 'Most people only paint them as lines. Look at the shadow cast by her lower lid, her lower lashes.' A pause. 'To really begin to see,' he continues, 'you must slow down. Just breathe.' His already deep voice deepens. 'Slow ... down...'

My own pulse calms. I don't move.

In the first few moments, this proximity is wired: electric, nervous. Now, the feeling has changed frequency, has become a studied quiet. Just what Bill wants. And the young woman, Sarah, is no longer looking at me, but *seeing* me. Under her trained painter's eye, I'm beginning to break apart into shape, shadow, texture, colour.

'The more you look at someone,' Bill says, 'the more beautiful you realise they are.'

The room is silent. Muted light slants through the win-

dow. Dust, from easels recently arranged, floats in the light. If I glanced into Sarah's eyes, the spell would break. I am meant to be here, but not here. I am meant to be available, but not available. I am meant to give myself wholly, yet remain at a remove.

Twenty minutes after our encounter, Sarah has left for the market, and we do it all again. This time, three more students – by chance, all women – stand hand's-length from me, and after their giggles and flutters cease, they too concentrate on the details of my face.

'Look at the darkest spots, just at her nostrils; at the corners of her mouth.'

Bill carefully holds out a white-ended cane, gesturing at my cheekbones, the bridge of my nose. He reaches out to push my hair back and one of the students excitedly comments on the shape of my left ear.

'She has a textbook ear,' Bill says. 'If I was trying to explain to a student how to paint the perfect ear, it would be this.'

His fingertips, pushing back my hair, are cool. Everything is cool: the light, the room, my skin and its tones. I am not myself; I am more myself. I don't know if I like being 'textbook'.

'Porcelain,' someone says.
What do they see?
'Beautiful skin.'

In Bruges, Bill Whitaker, 70-year-old master oil painter from Utah, and teacher for this month-long class, repeatedly tells me what a wonderful thing I'm doing for the artists. What an excellent service I'm providing. Working from life is a crucial part of a painter's classical training. Not a painter myself, becoming a model allows me to enter a world I wouldn't otherwise experience. It opens a door into thinking about art.

My usual modelling gigs are in London, for afternoon

classes, art schools, and individual painters. One regular class is comprised of a handful of retired, quiet people who like to offer me tea and biscuits in the break. Some of them are beginners, while others are skilled – a few had art training decades ago.

One lady once studied at the Chelsea School of Art, and comes up close to greet me when I arrive, murmuring, 'beautiful, just beautiful.' She seems venerable and frail. There is a tinge of the Grimm's fairy tale about her. I'm glad she wants to paint me, yet there's something absorbent about our encounter: as if she's breathing me in – *inspiring* me. If I could, I would paint this lady – her orderly white grin, dark eyes, and white hair, her floral-print dress, blue apron, and orthopaedic shoes – leaning close, peering at me through thick, wire-framed spectacles.

With many students, the experience is simple. These classes are a hobby they've come to, finally having the time to give it a try. I tell them about my upcoming trip to Bruges.

'For a whole month?' a blue-rinsed lady pipes up. 'So you're going to be a professional model, then?'

I'm taken aback. What am I doing in this studio in Greenwich, posing nude for the afternoon while she and her peers draw and paint me, if not being a professional model? Am I somehow unprofessional? A heartbeat later, I realise that she doesn't consider herself a 'professional' artist: for her, this is a relaxing, possibly challenging, afternoon class. In her mind, I am going to be posing for artists in a way I'm not doing here. In my mind, the levels of distinction are quite different.

December 2012. A *Sunday Times* article by AA Gill takes me by surprise. 'Return of the Nude' the cover cries, 'AA Gill revives the lost art of life drawing'. A modest charcoal sketch of the back of a man adorns the cover. Gill despairs that 'hardly any art schools have life rooms any more'.

He is wrong – life drawing is not a 'lost art'. It takes place

in private studios, in Conservatoires, in Community Colleges, in Ateliers: in hundreds of art classes across London, and beyond, all the time. Evenings, weekends, daytimes. I'm delighted to hear that a reaction is finally coming from art schools like Goldsmiths, where students are rejecting the influence of the Young British Artists and rediscovering the importance of oil painting.

Life drawing happens behind closed doors, behind curtained rooms, in studios where the light enters from high windows, and casual eyes cannot see in. There is a respect for both the model and the artist, for the space: for the privacy of the person and the privacy of the art. There is a studied quiet in the intimacy of the gaze: the only contact that should take place between artist and model. No matter how much or little one earns, the model makes a gift of his or her form to the artist, who tries to learn something from it. It can be in the nude, or seated, clothed, for a portrait. The success of the exchange doesn't matter so much as the exchange itself: a fundamental, wordless effort to understand the human form.

Equally misleading was Gill's choice of celebrity artists. They are not artists who exemplify the art of the nude, but 'big names,' in anything from cartoons to textile design to taxidermy. I have a classical bias, and I believe that any visual artist should have life drawing experience and an anatomical understanding of the human figure. But this article feels tacky. Gill can lament the lack of life drawing going on, but rather than point out all the places it is happening, he focuses on pop art – where there isn't much life drawing going on.

'Staring at a nude,' Gill writes, 'provokes profound questions about our humanity, the profound questions that should be at the heart of all art.' He gives no examples of such profound questions. One of Gill's artists for the experiment, fashion designer Giles Deacon, does his sketches on an iPad.

It reminds me of the time I modelled for John Bird, founder of *The Big Issue*. Bird was working on a series of drawings to be sold for charity at an exhibition he called *Naked Bird*. So I turned out to be one of Bird's 'naked birds'.

I think John and I surprised each other: meeting first in a Cambridge café, he immediately commented on how educated I sounded. I thought he looked like a mobster: he was balding, built like a fortress, and missing a tooth. He was also an entertainer. As I sat nude on a sofa in his office, he cheerfully talked for hours about himself – how he was the most promising art student in his class before he dropped out, about his seemingly endless list of wives and children, about founding *The Big Issue*, and about his sketches. He did each piece on an iPad. It was the first time I'd sat for anyone using such technology for the sake of art.

John was a respectful, generous person to work with, and no doubt a dab hand at a quick sketch. But to me, there was something lost in taking my nude figure and trying to communicate it in a few lines on a screen. It felt like the soul was taken out of the exercise. It was quick, not engaging: instant gratification, not a relationship. Technology didn't abet communication – it put something between us. The screen acted as a barrier, where it seemed the canvas could act as interpreter.

Perhaps the difference is sensory. I love oils, watercolours, charcoals and pastels – their textures and smells, their pigments and history. The grains and shades of paper and canvas. The dusty blend distinctive of an artists' studio. The gorgeous array of pigments in glass jars at Cornelissen & Son on Great Russell Street. These textures, smells and colours are evocative and romantic. I don't understand the point of all this if it isn't sensual and sensory – though that doesn't mean it must be pleasant or easy.

Gill writes – and here, I agree with him – of 'the complete attention a body demands'. One must succumb to that demand. Even if life drawing isn't their usual mode, the ex-

pressions on the faces of Gill's artists in the *Sunday Times* article is one of concentration: wide eyes, neutral or slightly pursed lips. They are not posing for the camera; they are at work. The screen detracts from that. From my perspective, the screen demands to be looked at in a way the canvas does not, taking the artist's eye away from his subject.

Yet in the studio in Bruges, I will be looked at, studied, in a way I've never experienced before. We have the space, the light, and the time – one month. One month of being scrutinised, one month of staying still. One month of posing – in the same position, every day. What will we see?

Chapter Two

*And moving thro' a mirror clear
That hangs before her all the year
Shadows of the world appear.* [b]

How did I begin? In my last year of undergraduate study, a number of friends were life models for art classes at my all-women's college. One friend taped up drawings of herself on her bedroom wall. When a handful of us were strewn around the lounge, drinking wine, the subject came up.

The most petite girl in our group, a gifted illustrator and painter, considered modelling to be a natural part of her work. After all, she needed people to pose in order for her to draw the human figure, and knew she should reciprocate. One dancer, charismatic, thin, and beautiful, did it for the money – modelling paid better than most student jobs, and models always left with cash in hand. A third friend, a strong, graceful dancer, considered it a way to celebrate her body. She found it empowering – she was the one who had proudly taped the pictures on her wall. The art history major among us wouldn't consider posing; didn't feel comfortable with the idea that her roommate might turn up one day on the modelling platform. She admitted embarrassment at the idea of having to study her friend's nude figure for a drawing class. Our philosopher didn't know if she'd have the confidence to disrobe in front of a room full of people. And the poet in the group – me – was curious to give it a try.

Put simply, it sounded interesting. I had Romantic ideas about modelling, inspired, predictably, by the Pre-Raphael-

ites. It may have begun with reading Tennyson's poem 'The Lady of Shalott'. I had a poster of Waterhouse's painting on my dormitory wall. That pining lady with flowing hair, in her white dress, floating towards her doom among the river reeds, epitomised a young woman's fascination with, take your pick – love, romance, yearning, mortality. Considering the poem now, Lady Elaine seems an ur-model: encased in her tower, framed by her loom, unable to move – cursed, in fact: forbidden to do anything but sit in front of a mirror. I considered Millais' *Ophelia*, equally doomed, equally floating. With time, I would develop a passion for Virginia Woolf and themes around water.

I wanted to claim sisterhood with those famous muses. The voluptuous myths surrounding both the characters and the models enchanted me. It likely influenced my desire to move to England before I'd ever travelled there. Looking back on these inspirations, I see they are predictable. But then, that is the cultural influence, the reach, from England, to a girl studying a literature degree in Virginia. I would later argue with a British friend about his contempt for the Pre-Raphaelites – 'They're *not real women* – they're saccharine fantasies by male artists who refused to engage with the world!'

But isn't that the fantasy? To be made unreal?

One day shortly after the conversation with my college friends, one of them phoned in a panic – 'I'm supposed to model this afternoon, but I need someone to fill in for me! Can you do it?'

There wasn't time to second-guess. Yes or no?

'Ok.'

That afternoon, I found my way to the art studio. I'd looked up some tips about modelling, and brought along a robe and slippers. The teacher was a friendly man, probably in his sixties, who had been running classes of female students with female models for much of my lifetime.

'A good start is to just lie on your back with your legs up the wall,' he said. 'Always an interesting pose.'

He told me that people usually know they can model, or know they can't. But 'sometimes, when the moment comes to drop the robe, they freeze'.

If you get as far as the 'robe-drop moment' and freeze, I wondered, do you know yourself very well?

I dropped the robe, laid down on the platform, and stretched my legs up the wall.

Chapter Three

Taste them and try:
Currants and gooseberries,
Bright-fire-like barberries,
Figs to fill your mouth,
Citrons from the South,
Sweet to tongue and sound to eye;
Come buy, come buy. [c]

AFTER COLLECTING ME from the train station in Bruges, the woman who runs the Atelier drives me to my accommodation. She's rented a room for me, but it turns out that the landlady has in fact given up *her* bedroom because her two guest rooms, en suite, are let. It's a cheeky move on the landlady's part; one my employer did not expect.

I will learn that in this expensive town, people are extremely tight with money. The landlady herself says it: 'Belgians are cheap'. Do not ask to be served tap water in a restaurant, even though the tap water is perfectly good to drink. Do not expect to return an article of faulty clothing without a serious argument. Indeed, there are stories of *chefs* telling off *diners* if the customer has a complaint about his meal. And I'm about to learn that a woman will rent her own bedroom and sleep in her laundry room to squeeze funds from another lodger. Later, I'll wonder whether I should have protested. But it's too late: I'm dropped off, and the newness of everything means I stay quiet and adjust. The landlady has decamped to the back part of her house, separated by a hallway and a locked door. For the first half of the month

I have to venture back there for a shower, fending off her friendly but poorly-trained dog. Because the door is locked, I can only shower when the landlady is home. Each time I tiptoe in with an armful of towels, the black fluffy Louis leaps on me, slobbering with excitement.

I have to climb a ladder-steep, ladder-tall set of stairs to reach the kitchen, and another to reach the loo. One of the let rooms is locked, and I wonder if I'll ever meet its inhabitant, a student who is away at his parent's house. The other room is occupied by a twenty-year old girl from Amsterdam, who is completing work experience at one of the most elegant hotels in Bruges.

My bedroom – the landlady's room – is on the ground floor: it is large, square, with a high ceiling and one huge window, draped with curtains I'll keep permanently drawn. During the morning and evening 'rush hour,' there is a mellow stream of motorbike and auto-traffic. My favourite sound is the clip-clop of hooves as tourist carriages head into town in the mornings, and home in the evenings.

There is a large bed, a washbasin, a desk. The strangest thing is a tiny camping toilet. I'm not sure if this is a permanent feature of the room, but considering the nearest toilet is up two dark, treacherous flights of stairs, I quickly accept this as a middle-of-the-night necessity. It is a strange source of embarrassment: when I later invite a friend from the atelier over for lunch, I don't offer to show her my room. I tell someone in London about it, and he describes it as 'appropriately bohemian'. The house is near the Langerei canal, a windmill, and a pub, in a residential, quiet part of Bruges. I'll come to love the neighbourhood, if not the accommodation.

I understand better now the discomforts of poor, uncomplaining Lizzie Siddal, who nearly froze to death in the bathtub when the candles went out while Millais worked on painting *Ophelia*. Through the discomfort – danger, even – comes an impoverished romance. Viewers of fine art might

not consider that most of the sumptuous fabrics in paintings are, in fact, paint-spattered rags, or that the elegant chaise longue across which the model drapes her naked self has been dragged from a skip. Perhaps, if the painting is a success, it doesn't matter.

The art classes for which I model are almost always in beautiful, mouldering old buildings: the one constant is a big window, or better yet, many big windows. It is all about the light. The fact that the loo next door is broken and I have to walk down the freezing stairs and along the freezing hall in my robe and slippers to get to the toilet is of little concern to anyone. Art teachers inhabit their surroundings with demeanours ranging from dignified resignation to utter defeat. I'm lucky if I have a bathroom in which to take off my clothes and put on my robe. Usually, it's a busted-up tri-fold dressing screen in the corner of the room. Once, there was nowhere to change, and the teacher blithely said, 'Just go to the corner and take your clothes off.' I didn't pose for her again.

I unpack my month's worth of clothes into the wardrobe in my borrowed room in the 'bohemian' house. Even in June, my summery dresses and skirts will prove inadequate in these blustery, wind-wracked flatlands. I will wear jeans; buy jumpers. Once unpacked, I walk down the road and along the glittering Langerei to the Atelier. It's ten minutes away, and when the landlady lends me a bicycle the following week – I'm astonished she doesn't charge me for it – I can get there in five.

To reach the Atelier, one must pass through a portico beside the canal. The portico has tall doors of thick, heavy wood painted a faded blue-green. Two windows, outlined in the same pale green, stand tall on either side of the doorway. A double-arched panel tops the doors, and above that, in plaster relief, is an image I can't quite make out. I decide it is a Madonna and Child. The tiered roof holds two stone

vases on the first level, and two, streaked green with rain, on the top.

The right side of this great double door is open a few inches, revealing a cobblestone drive leading to a large grey-roofed building of pale red brick. I have to lean my whole weight against the door to push it open and slip through. I feel fantastically small, and an image comes to mind: the scene at the very end of the film *Girl with a Pearl Earring*, when the camera zooms out on Griet, standing in the cobblestone square in the Dutch village. The artists' model feels utterly alone, unique, and at the same time part of a long tradition that effaces the individual, like a stone sculpture whose features are worn away over time.

The old brick building looms chalky red in the slate-bright light. It's a former government office, now renting rooms to a cookery school and the art workshop. Our studio is on the entry level, up a flight of stairs and through another imposing arched doorway. The building seems empty. Everything echoes.

The studio is in a large room lined with two rows of pillars, making up what used to be a central walkway. Metal tracks set into the floor indicate bookshelves long gone. The high, long windows are deliberately boarded over, only leaving a few panes uncovered at the very top. The walls have hastily been painted military green, a 'neutral dark,' and the lights are off. The studio is so dark that, until one's eyes adjust, it seems abandoned. The watery, grey-blue light forms a gentle spotlight. Next door, there's a lounge with an old chintz sofa and two armchairs, and a large table where people have lunch. We have a two-hour lunch break, and I take to going home, or going for a walk – to escape the studio and lift my eyes to the sky.

In London, the most elegant space in which I've modelled is, not surprisingly, in Chelsea. The studio overlooks the Thames and the cheerful pink-and-white of Albert Bridge.

The room is high up, with a whole wall of windows. The building is a converted warehouse, new inside. There are two loos and one of them has a shower – I've never used it, but it seems an outrageous luxury. The big room is very long: one half is carpeted, devoted to a lounge and office space, while the other half, against the windows, is a raised, wood-floored studio. The kitchenette is as paint-spattered and tea-stained as any other, but at least it is always stocked with tea and biscuits.

One teacher, at a much poorer community college, in South London, balefully offers me a bottle of water whenever I sit for his class. The kitchen and toilet are 'out of order'; notices taped to the wall request patience while they repair the broken heating system. I see those notices in October: I'm doubtful whether I'll agree to sit through the winter. Being cold is the bane of a model's work.

On the first day in the Atelier, we spend hours deciding on a pose. I will be in it for a month, so we must get it right. I try curling on my side on a settee, first like Velázquez's *Rokeby Venus*; eventually more like Cabanal's *Phèdre*. But there is no heat on in the huge old building (it is, after all, June,) and the tiny space heaters simply aren't enough. Bill is very aware of my well-being, and I'm lucky – some of the students are impatient, and it could have made for a very different experience.

'We can't have you being cold,' Bill says. 'The first thing is your comfort. It would do no good to any of us for you to come down with pneumonia.'

I'd been nervous about what Bill might be like. Emails from the Atelier coordinator – the same woman who'd arranged my unusual accommodation – passed along messages like, '*Tell our model to stay out of the sun!*' Email didn't communicate Bill's warm, joking humour, his teasing way of being, in fact, very caring.

One student is so eager to paint, it doesn't occur to her that I might feel cold.

'I'm warm!' she says with irritation, paintbrush in hand.

I'm amazed at how many artists don't seem to think of the temperature difference depending on whether one is wearing clothes or not. When modelling, I *will* get cold. I am standing, or sitting, completely still. And *naked!* It doesn't matter how warm it is outside: I will need an external source of heat. I become reptilian, cold-blooded: unless I'm being warmed from a heating pad, a fan-heater, or sunlight, I will be cold. Frequently, when I pose, I have an infra-red image in my mind, which shifts from pink to purple to blue over the course of the class.

By the end of the first day, I'm exhausted. I've been very, very cold for the better part of four hours, and we've concluded that a nude pose simply won't work. The impatient woman is also now annoyed, as if she's not getting her money's worth.

Bill announces that a nude pose isn't important. The hardest thing to paint is a person's face: we're going to focus on that.

We set up a pose where I am mostly clothed. I'm sitting in a chair, wrapped in blankets to my waist, with my feet flat on the floor. I'm wearing my pink silk robe, draped off my shoulders, clutched just above my breasts with my left hand over my right. My shoulders and clavicles are bare. My wrists and forearms are bare. My hair is down, reaching in dark waves just past my shoulders. My skin is very pale. I look ahead, a little to the right. We drape a dark blue cloth behind me. The next day, someone conjures an electric blanket, which I gratefully sit on, and we figure out how to stop blowing the fuse on the plug-in heater. I can baste on a low heat setting for the month: there will even be a few unexpected days when I can turn the heater *off* – though I'll keep the blanket.

Much later, on a cold September afternoon in London, I will pick up a frog from a log pile in the garden. Rather than struggle to escape, the chilly amphibian snuggles into my palm, soaking up the warmth from my hand. I understand how it feels.

Chapter Four

Calm was the day, and through the trembling air
Sweet-breathing Zephyrus did softly play
A gentle spirit, that lightly did delay
Hot Titan's beams, which then did glister fair [d]

'What a beautiful pose. It reminds me of the Mona Lisa.'

'Oh yes,' Bill says, 'Kelley did this for Velázquez, back when she posed for him in 1638.' He winks.

Later, he sets up a laptop and shows the class – six students, aged twenty-five to fifty – photos of paintings.

'This is called *Lady Kelley Swain with a Fan*,' Bill jokes, and half the students gasp.

'It looks just like her!'

There are murmurs of amazement.

It is a picture of a pale, dark-haired woman with an oval face and large black eyes. She's wearing an elegant black bodice lined with white lace at the bust, a short necklace of round jet beads, and white gloves. She has a black lace veil over her hair, draping down her shoulders, and she's holding a black fan. Her cheeks have a slight flush and her lips are a soft pink. Her hairline is high, and her straight nose ends with a gently rounded curve. A rosary is suspended from her left wrist.

Half of the class thinks Velázquez's painting looks just like me. The others see some resemblance – dark hair, pale skin – but nothing more, far from my twin. For those that agree with Bill, I wonder how much of the resemblance is dependent on the power of suggestion. Perhaps, for someone who

is in love with the works of Velázquez, I simply 'match' the portrait more readily than it matches me – *The Lady with a Fan* exists first in Bill's mind. *I'm the shade, the shadow.*

'She's in the Wallace Collection in London,' Bill says. 'When you get home, go say hello to yourself.'

It is windy along the dark waters of the green-grey Langerei, and clouds move rapidly across the sun. Gusts of wind kick ripples across the stone walls of the canal. The sun is out one moment, warming the cobblestones and lighting up the pale green trees. The next moment a cumulus cloud passes over, and silver stone becomes steely, cold. Smatterings of rain wash regularly over Bruges, leaving as quickly as they descend. A cormorant pokes its head from the canal, gives a periscope-turn of the head, and disappears. A swan waggles its tail in irritation. Vespas, old BMWs, and bicycles rattle by. At times, all is still, the traffic ceases, the sun shines. Other times, the wind knocks and pulls, buses rumble, and crowds of tourists mumble past. The Belfry chimes in the distance.

It is the light, they say. Swift skies, with constant, glowing light, that brings painters to Bruges. What is this light? It is the light of the Old Masters: the light of Jan van Eyck, Hans Memling, Johannes Vermeer. It is crisp and clean, like spring water. It is the glint through a glass prism, the slate and steel of a rain-laden cloud. It is the fresh blue, insistent and flat, always stretching behind the Constable-cumulus clouds and sprawling dark thunderheads.

Changing cloud-cover and quick shifts from sun to rain mean the light is always turning: now bright; now dim.

'What happens if the light goes altogether?' I ask one afternoon as a storm rolls in.

'You have a nap,' Bill says, 'and in a few minutes, it'll be back.'

It is the transient, dynamic movement of European weather: that unpredictable motion of the air that means I never have an umbrella at the right time. It is the constantly

scrubbed sky, the sometimes-warm sunlight. It is the insistently varying wind, blasts sweeping across these flatlands so close to the sea. It is a clean light; a light whipped fresh but not bruised.

One afternoon, the air thickens and I sweat on my easy walk home. Half an hour later a thunderstorm rips over Bruges and rain pours down.

This light comes from the freshness that follows purged skies. During the storm, ducklings and goslings hide in the canal-side beds of foliage. An hour later, all is clean and sweet again. The birds venture out from hiding, the tourists resume their boat-tours, the punters renew their street hijinks, and the painter wakes from his nap, and picks up his brush once more.

I sit, in the blue plastic chair, wrapped from the waist down in the pink blanket, from the waist up in my pink robe. Strange: I've never much liked pink. The blanket is dusty with charcoal and smudges of dried oils. Fragments of tapestry – fabric, sheets, curtains, old clothes – are a familiar part of studio scenery. Scraps of drapes; settee cushions with no settee. Stained with pastels and paints, these serve as the backdrop to sit on, lay across, or stand in front of.

The cloth is selected for its colour or texture; I'm often placed against a dark background, to set off my pale skin. I sit or lie, usually nude, on these fabrics, on old mattresses and broken chaises. The fabrics are folded at the end of the class and tossed back into the cluttered pile from whence they came, probably never washed. During breaks, I wear black ballet slippers and my black velvet robe. If I walked barefoot around the studio, the soles of my feet would become black with charcoal dust.

For them, painting a figure from life is all about seeing. It is about learning how to paint what you see, rather than what you think you see. It is about light: light enables us to see.

Bill is demonstrating a painting technique for a student. They face me, so I can't see what happens on the canvas, but I listen.

'See? I'm not painting the thing, I'm painting the light on the thing. Now, I'm beginning to sculpt her in paint, starting with the lightest areas…'

I blur between being an object and a person: 'the thing,' and 'her'. In this case, the more they concentrate, the more I become something to look at. At the break, I'm back to being my animate self. Whether or not I am the object, and whether or not they think of it, I am observing them, too.

For me, posing is all about time.

'I sit,' I write to my mother, 'they paint.'

This is the essence.

But try it. Try sitting in a pose that you think, at first, is comfortable. Try not stretching your neck when it begins to ache. Try not scratching your ear when it begins to itch. Try not sneezing. Try keeping your eyes open, focused on the same spot on the wall. Try being still. Try not rolling your shoulders, not passing wind if you need to, not falling asleep, and not talking. Try not to think about whether you are hungry or need the loo. Try it when you're hungover, when you haven't slept well, when you have a cold, when you have cramps, or when you're menstruating. Try it for five minutes. Not bad? Try it for forty.

Comfortable? Try it in the buff, in England, in January. And remember, it's for a room full of people you've probably never met.

As someone who began learning to use fine oil paints when he was six, Bill is the most experienced artist I've ever had the privilege to work with. The first thing he did when I met him was to hand me a little stainless steel kitchen timer.

'You are in charge of the time,' he said. 'Twenty minutes, and then a five minute break.'

This timer will become the quiet heartbeat of the class, its

little '*brring!*' a surprise to all of us when we're concentrating. The bell is always a relief to me, no matter how long or short the twenty minutes feel.

I walk home for lunch, my footsteps matching two horse-drawn carriages, *Pardetraams* from just down the road. I wonder if the men driving the carriages are also going home for lunch. The steady clop, clop, clop of horse's hooves is one of the sounds that accompanies my days in Bruges.

The other sound, which seems constantly in the distance if I listen out, is the Carillion from the Markt belfry. It has a comforting, music-box variety of melodies, familiar, yet – thankfully – not familiar enough to become stuck in my head.

Bells are always pealing somewhere in Bruges. My days, my poses and breaks, match the bells of three nearby churches. The nearest seems also to be the most regular, ringing out the hour, chiming once on the half-hour. This nearly matches the routine we set: I pose for 20 minutes and then take a 5-minute break. The church bells help me keep track of time. I eat a banana, on most days, at eleven o'clock.

At noon, I know there is one more 20-minute pose before lunch. At noon, the nearby church rings out twelve steady bells. A few moments later, a bell peals in three sets of three, with pauses in between. Three … six … nine … I wait for the final three, but they never come. It will be the same each day. At noon, following the nine bells, one church farther away rings out seventy times in quick succession. My left ear listens to Bill as he explains corrections and angles to a student, while my right ear counts the bells. The last trails off with five further, irregularly spaced notes until it fades.

The students concentrate on painting. Yesterday, just after the three churches had, in their various ways, rung noon, someone asked for the time.

With the class full from lunch and deep in concentration, afternoons are often silent as the grave. Indeed, some peo-

ple refer to Bill's style of lighting as 'Whitaker's Tomb'. The windows are taped up: only the very top panes aren't covered. Natural light slants down like a spotlight. The overhead fluorescents are always off. If someone walks into the studio when we're at work, for a moment, it seems like the room is deserted: the six students and Bill are working on their paintings, and I'm still as a statue. But once one's eyes adjust, the metaphor is livelier. Art is being made here; six versions of me are germinating, generating, being grappled into existence. Seven versions, counting the flesh-and-blood one, who at the age of twenty-seven is certainly grappling with becoming.

While the afternoon atmosphere is often one of concentration, mornings are interspersed with questions and chatter. I hold the same pose for the entire day, but after lunch, we move my seat, heaters, and backdrop to the other side of the studio, moving with the rotation of the Earth, from sitting in morning light to sitting in afternoon light. Bill has divided the class of six students into two groups: three paint me in the mornings while the others work on still life projects, and in the afternoon, they swap. A few of them will come to hate a particular red apple, but that apple will begin to look real on the canvas.

The morning group gossips about people they know in the art world, while the afternoon trio talk about books and sightseeing. There is debate about the best place to find Belgian *frites*. Bill enjoys referencing old films, especially Westerns, when he isn't giving history lessons about famous painters.

'Kelley travels through time as well as space,' he jokes. 'Here is a reminder of when you sat for Von Amerling, a great 19th century German painter,' he says, showing us a picture of *The Oriental*.

'The second image is one Von Amerling did when you modelled for him in 1837,' Bill says.

Both paintings are of pale young women with dark hair,

straight noses, and faintly pink cheeks. These are two versions of *The Oriental*, very similar, one in warm orange-gold tones and one in cool green-blue. The woman is the same model, in different exotic dress, with embroidery and a regal turban. She's leaning over an open book, which I particularly like.

Some days, when the sun dips in and out of clouds, the silver-grey light darkens so much that the students struggle to see. It's authentic for the style of the Old Masters. Well before electricity, there was no choice but for painters to work by daylight, candlelight, or firelight.

A combination of fluorescent lighting and colour photography has made people appear increasingly orange, both in art and life. Many make-up obsessed Western fashions have gone in for the fake tan look, emulating what one sees in print. Whenever I go near a make-up counter (a rare occasion) I am offered foundation, bronzer, and blush. My skin, called 'English rose' by some, unsettles others. I wear sun cream if I'm ever at risk of tanning and if I do catch some sun, freckles appear across the bridge of my nose and along my arms. Bill thrills over the 'Northern European translucence; the pale, almost non-colour' of my skin, which is perfect for studying the Old Masters, for scrutinising the van Eycks in the Groeninge Museum, for contemplating the pale skin of the female subjects. There is much discussion of the shadow just on the outside corner of each of my eyes, not a cast shadow, rather a tiny, natural brushstroke of darker skin.

In the autumn following my time in Bruges, I begin to sit for my friend Cassie, whom I met and began working with through researching her family for one of my books. My interest in her ancestors, the Herschels, discoverers of planets and comets, ran in parallel with Cassie's own creativity, and she's taken up an MA project, constructing an historically-accurate image of her ancestor Caroline Herschel, the hero-

ine of my novel. In a surreal completion of the cycle, Cassie has asked me to sit for her preliminary sketches of Caroline, in full skirt and bodice-style dress, by a fireside, writing.

One October evening, we are in Cassie's lounge: I pose at a makeshift 'standing desk,' like one Caroline Herschel used to use. I hold a fountain pen in one hand and a shell in the other: the shell stands in for a wooden worry-bead Caroline often held. The window, with the setting sun in the west, is to my right, and the warm glow of Cassie's coal fire is in front of me.

To my left, Cassie, fair-haired and birdlike, perches on the arm of her sofa, watercolours balanced on the cushions beside her. She has been painting for several hours.

'Ah,' she finally says, 'the light is going now, I can tell. I'm finding it hard to distinguish the difference in colours. The rods in the eyes function better in low light, but don't pick up colour.'

Cones are the receptors in the eyes which register colour, and require more light in order to function. I'm wearing a forest-green silk skirt and a brown long-sleeved top; the two colours begin to blend into one as the light fades and the cones in Cassie's eyes shut down for the evening.

In the Atelier, one student is completing small studies of eggs, not much larger than three square inches. It is an exercise: paint an egg from your imagination. Later, she'll give me one as a gift. The egg she's painted is brownish-white and slightly oblong, like a duck egg.

'I have to get the egg to *turn*,' she says.

'So it looks spherical?' I ask.

'Yes.'

A convincing egg depends on how the light hits it, and that depends on how white paint is used: in precise, studied dabs.

'Aim above it, aim below it: eventually you'll hit the mark,' Bill says. 'If you miss, don't worry. If you mess up, don't

worry. It's paint! You can paint over it. The best paintings are layers and layers, built up.'

I'll realise some months later that this applies to oils and acrylics, not watercolours. But for now, I watch, and listen.

How do you weave a carpet in paint? Cinch chain mail? Sew a robe? Curl hair; smooth a feather; illuminate gold? Turn stone; blow glass; polish tiles? Bring flesh to life?

Van Eyck did.

'He can be considered the father of oil painting,' Bill says. 'I'm going to sit here and look at this for a long time.'

We are in the Groeninge Museum: me, Bill and his wife Sandra, and two of the students. We've come to visit the Masters, and Bill is here on no less than a pilgrimage to see *Virgin and Child with Canon van der Paele*, painted around 1435, by Jan van Eyck.

'You must paint the light on the thing, not the thing itself. Pull apart the values using some *thing*,' Bill says, referring to the gold pattern on the royal blue cloak in the van Eyck. 'Where is something shiny?' I hold up my hand: my champagne-brown diamond sparkles. 'See? You go from a bright light to a dark.' He stands, brings his nose to within inches of the painting. 'Look at how *dark* the dark is beside the light.'

There is luminosity to the painting that we'd like to understand, but despite analysing the gold, breaking it down into 'white and yellow,' the painting is something more than the sum of its parts.

As Andrew Graham-Dixon tells us in *The High Art of the Low Countries*, though the practice was already around, 'van Eyck did, in effect, invent oil painting: certainly ... he discovered the things that could be done with pigment when it was suspended in this medium of oil.[e]'

'They had an extreme reverence for what they were painting,' Bill says. Perhaps this is the secret to the luminous glow. 'Real art lies in sensitivity. If their paintings of you are successful,' he says to me, gesturing to the students, 'it will

become a super-natural, spiritual painting. People will look at it a hundred years from now and they'll be able to relate to you. You'll still be alive on the wall.'

Chapter Five

Every portrait that is painted with feeling is a portrait of the artist, not of the sitter. [f]

'Don't you hate to see paintings of yourself?' people often ask. 'Oh, don't look, it's terrible: you're much better-looking than that,' they say.

'I don't paint at all; it looks good to me!' is my invariable answer. I have no problem with seeing awful paintings. Which is good, because I certainly do. I see plenty of skilled paintings, too. There is a disassociation from myself and those pieces of, or attempts at, art. It's especially odd to hear stories of models disappointed by representations of themselves. Surely, they've got it the wrong way round: those representations are not about the model; they are about the person doing the creating.

The students are not in Bruges for me, they have come to work with Bill. They didn't know who their model would be until we all met on the first day of class. In day-to-day life, I can look so different that even close friends don't recognise me. I change my hair, wear different spectacles (or contact lenses) and can almost be in disguise. Maybe this fluid style enables me to accept the range of images people create from my face and figure. There isn't one set version of myself, and I don't want *one*. I enjoy expression, variety, and clothes too much to limit myself to only one look. And I suppose going without any clothes allows for yet another version, yet another way to understand or represent myself.

Some paintings, of course, are better than others. In Bruges,

three of the students in the class, plus Bill, are some of the best painters I've ever worked with. But even the painting that becomes my favourite, which I think is the best, doesn't necessarily look *most like me*. It is the style I like the most: the delicate touch, the lightness of the brushstrokes, the luminosity of the skin. And this painting of me – Sarah's – looks just a little bit like Sarah herself. I wonder if she has struggled less with painting me than some of the students because we are most alike in the class, physically: we are the same age, pale of skin and dark of hair. We are similar in size and shape. We are vastly different in personality, and I think we look different too, but on the surface, I wonder if Sarah can capture me just that little bit more easily. She's also incredibly skilled, which I'm sure has more to do with it. And she's quiet: so quiet; if she's struggling with her painting, we'd hardly know.

'I always paint the eyes too big,' one student moans.

'That's because you have big eyes,' I say. 'Everyone always paints themselves. You know yourself best.'

It's unconscious, and it always comes through. The more paintings I see, the more I see the artists in their paintings. When men paint me, I am more masculine, more angular. A round-faced woman paints me with a round face; a doe-eyed girl paints me with large eyes.

In one London class, a man gives me his painting at the end of the session.

'You were giving off a yellow-orange aura today – you seemed to want to be painted orange,' he says.

I take it, thanking him. The standing nude is scraggly, the face square. I think, 'No, my dear, it's *you* who feels orange today.'

But this is good, for what is art if not an outlet of one's emotions? If I'm a conduit for people's expression of themselves, if I can help them reach a level of catharsis, or accomplishment – isn't that my job? *Is* it my job? There's no contract, but it seems to come with the territory.

When, in my everyday life, I refer to myself as 'an artist,' I mean as a poet. The best poetry offers a small, prismatic – suspended, yet infinite – moment of contemplation. A cut-glass piece of thought.

My favourite art does the same. It offers a mandala, a sensory feast, and above all, a break from the hectic, every-day-ness of urban life. One of the greatest pleasures of living in London is the freedom to pop in to the National Gallery, where I allow myself to wander through rooms until something catches my eye; or to head straight to my favourite rooms in the National Portrait Gallery, to visit the 18th century thinkers, scientists, and poets. Each time, I feel as if I'm saying hello to old friends.

I hope my work as a model offers this kind of break to others. They want to stop in the midst of things for several hours, at least, and create a scene of stillness. Even painters who are busy with their brushes, who pop up and down from their seats for paper and turpentine and can't get their easel quite right, are chasing stillness. And when the moment does settle down, and the feeling suspends, it is like the room has sighed a common breath of relief. That, to me, is success.

The first time I sit for the professional portrait artist Rob Wareing, who is especially skilled at children's portraits, he makes me look younger. When I ask him how old he thinks I am, he guesses twenty-three. I tell him I'm twenty-six, and the next portrait he creates seems to fit my age more closely. Both images are incredible pastel demonstrations: in 40 minutes he's drawn an accurate portrait. But at first, he captured a younger me. I imagine that Rob's disposition towards making people appear younger is naturally flattering.

In the Atelier, Bill tells us a story of doing just that.

'I was commissioned to paint a portrait of a couple, about my age. The wife – a lovely woman – suffered from terrible arthritis in her hands. I did the painting, and then I used one

of my apprentices, who I use as my hand model for everything – she has beautiful hands – to model the hands for the portrait. When the lady saw it, she cried. She was thrilled to have the hands she'd had when she was young.'

Tears come to my eyes as Bill tells the story. The painter has the power to undo the ravages of time. Is this flattery? Perhaps, but it is also wisdom, and grace. More often we think that the painter has the power to capture someone's image whilst the sitter is still young, but the powerful manipulation of time can work in both directions.

It can be especially difficult to please the subject of a commissioned portrait. Laura, one of the women in the class who becomes a friend and confidante, describes the difficulty inherent in pleasing clients. How the artist sees and how a sitter sees are not necessarily the same. A portrait, says Laura, needs to be flattering, but real. She will come up with numerous sketches and ideas to share with a client before committing her time and effort to a portrait, and there is always the risk of a sitter rejecting it in the end. There are, of course, economics to this power structure. For a portrait, the subject is paying the artist for a painting of herself. As a model, the artist is paying me to be a body in space, and the artist can paint whatever, and whomever, she wishes.

Both Bill and Rob are practised in consciously, or unconsciously, flattering their subjects. It is usual to see artists struggling, at first, to create as precise an image as they can of what they see. I find, however, that those more willing to let go, to allow freedom and movement into their work, create more convincing paintings, whereas the former are often strained and stiff. Striving for precision and missing the mark is far more awkward than aiming for a general impression. I often favour impressionism over realism. The former allows room for the viewer's imagination. Visually, I experience the less exact as more true, until it crosses some difficult-to-define boundary into abstractionism and risks falling apart entirely. It is the risk, though, that is exciting.

Back in the class in Chelsea, one year later, I'm sitting on a densely cushioned, armless chair. I wear a blue silk double-breasted smoking gown, off my shoulders, and am holding my 1965 Gibson ukulele. The students are tickled that I can actually play the instrument, and while waiting for them to set up in the morning, I amuse them by strumming a few tunes, but during class, I'm still, and silent. It's a three-week pose, for only one day each week, with an advanced group.

In the second week, I speak with one lady in particular about hands. She's had an inspired afternoon, has allowed a freedom of brushstrokes to capture the impression of movement about my hands that suits the ukulele-holding pose wonderfully. She's surprised herself with it.

In the third week, it seems she's had second thoughts, because when I walk around during a break, she's painted in the fingers more precisely, outlining them with thick lines of paint, and the image has become stiff; muffled. The movement – the music – is gone. I don't mention it, but I'm disappointed. Judging when to stop is just as important as judging when to continue.

On a holiday in the South of France, I visit the Matisse Chapel. The Chapelle du Rosaire de Vence is a tiny place, unassuming on the outside, striking within. Though I'm impressed by the intense colour streaming through the green and yellow stained glass windows, and though I avoid the intimidating docent keen to describe each aspect of the stations of the cross on the wall, I find myself most intrigued by a simple postcard for sale – a sketch by Matisse of a pair of hands. Long, lively, and thin, the hands are convincing. Despite being disembodied, they look real.

I buy the postcard for Cassie, who is also interested in sketching and painting hands. When we discuss the image, she calls it more of an impression, 'the idea of hands,' than a precise depiction.

Perhaps, like a nose on a face, hands aren't something we

stare at directly for any length of time. When we consider, or speak to, a person, we tend to look towards their eyes or mouth, not their nose. We look beyond, or around the nose. So a gentler, softer, or blurred nose works better in a painting. It doesn't look right to stick something in the middle of the face with hard, defined lines, because that isn't how we see. We don't tend to see hands that way either. When we interact with people, our hands rarely hold still. I grew up with everyone joking that they 'talked with their hands,' gesticulating and waving as they spoke. Our hands are usually busy. So perhaps precise hands look like dead hands.

What is a portrait?

The first time I sit for Rob, he is visiting from South Africa, running a special portrait workshop in Greenwich. Rob is a small, sun-bleached man, probably in his late 60s, with smile lines around his eyes and a white beard stained yellow from the pipe constantly held between his teeth. He is quiet and gentle and smells of the maple tobacco he smokes. What I will learn from him is more through osmosis than conversation.

I've never sat for a portrait class before: indeed, it's rather odd to keep my clothes on. Yet it turns out to be far more intimate than any of the nude poses I've done. Here, the artists are endeavouring to paint *me*. They are looking, very closely, at my face. Sometimes, with my permission, they come close, staring into my eyes to ascertain the exact colour. I stare into the distance, at the wall, at an earlobe. The colour of my eyes is troubling. Green or brown? They have red here, gold there. Most settle on calling my eyes 'hazel'. I am not looking into their eyes. Who knows what colours theirs could be?

When I begin to read about Sartre's concept of 'the gaze of the other', it makes a great deal of sense. So this is why I find portrait modelling more of an exposure, more penetrating. The philosopher Thomas Fuchs describes meeting the gaze

of another as being 'torn out of the centrality of my lived-body [to] become an object inside another world. The other's gaze decentralizes my world'.[8] There is an inevitable power struggle when two gazes meet. In this case, I always choose to relinquish; these connections happen in fleeting seconds, but when they do, I make an effort to disengage so I am once more an object. Sartre called it *corps pour autri*, 'body-for-others,' and in this case, that is precisely what I *want* to be. In this context, I am a body for others.

Sitting for Rob's portrait class is exhausting. He perches me on a tall stool with no lumbar support and pulls a bright, hot lamp close to my face. He is kind and patient, but inevitably becomes lost in his work, rotating a handful of pastel nubs in his hands that are dusted with a hundred colours of similar, skin-toned hues. I don't move for well on an hour. Beads of sweat run behind my ears and along my hairline.

Rob can tell how hard I'm concentrating on keeping still, and jokes gently. 'You can move now,' he says. 'You can breathe.'

A friend, who had never posed before, but volunteered, out of curiosity, to model with me, bows out after the first agonising day.

'I don't know what I was thinking,' he gasps during the lunch break, rubbing his back. 'I can't possibly do this for two more days. It's torture.'

He refuses the fee for the day he's earned. I feel sorry: it's an unusually harsh initiation. He'd make a good subject, with his crooked Roman nose and pale eyes. But it's not to be.

'I fidget,' he says. 'I don't know why I thought it would be a good idea; I don't sit still.'

I raise an eyebrow. He's right. A model must at least be able to sit still.

'I would call this 'head of a woman,' the teacher in Chelsea explains. 'It isn't a portrait, because I don't really know you. If it was a portrait, I'd have to get to know you, to capture your character.'

One of her works hangs in the National Portrait Gallery. It's full of movement, full of life: a loosely painted head of a lady with short black hair. I wonder if she knew that woman. If it's in the National Portrait Gallery, is it a portrait?

I appreciate her distinction, her definition, of what a portrait is, or at least, what a portrait isn't. I've sat for her class for two weeks. On the first day, she handed me a Prada dress of grey boiled wool with red piping, and set me up in a straight-backed, seated pose, in the wool dress with a white shirt underneath, and a thin red belt. I wear nude stockings and tan leather brogues. My hair is pinned into a high bun and I wear red lipstick. I can see out of the window to the barges moving along the Thames. I can see the pink and white of Albert Bridge. I want to live in this studio. When I sit, I frequently decorate whatever studio I'm in, imagining what it would be like as a fabulous loft apartment. When I sit, I have plenty of time to pick out furniture and hang curtains.

Two students at the Atelier agree that they aren't painting my portrait either. They are getting to know me throughout this month, but when I put the question to them, and to Bill, in the Groeninge Museum, I feel he misunderstands.

'They have time to look at you so closely, they'll almost be able to get to the molecular level,' he says.

'But that's the biological structure,' I say, 'what about getting to know *me*? Would that make a difference to the painting?'

That's when they agree it won't be a portrait.

'They'll be able to reach something almost spiritual,' Bill says.

But I'm not sure how I feel about my own spirituality. How then, can they? Bill is seventy, and Mormon. I'm twenty-seven, and altogether uncertain about religions. The students are a mixed bag of beliefs. For half of them, I'd wager that painting is more about neurosis than spirituality. For half of them, it is more about skill. Bill has the lifelong experience,

the certainty, to consider his work spiritual and, indeed, his pieces are crafted with reverence, the like of which infuses van Eyck's works. Perhaps this is why Bill finds van Eyck such an inspiration. As for me, I'll have to wait, to see what these paintings become.

In the Groeninge Museum, there is a self-portrait of a young man. The painting draws me to it, in part, because he looks as if he could be alive and walking around today, and, in part, because I find him very attractive. The label says the artist was twenty-eight: almost my age. Is that why I feel I can reach out and touch him? As I stare, his face transforms slowly into that of my love: his eyes become my love's eyes. I can feel my fingers in his hair, my hand stroking his cheek. I want to touch the portrait; I resist. Is he so familiar because he reminds me of the one I'm missing most? The artist has captured himself in his painting. Is the painting convincing because it is a self-portrait? If artists paint themselves into a portrait, then does this image, created over two hundred years ago, capture what the young man looked like? Could he be an ancestor to the man I love?

Roland Barthes describes, in *Camera Lucida*, the experience of a photograph which he felt 'transcended itself' upon his viewing it: the photo was of a young boy leading a blind man. But it was the texture of the dirt road beneath their feet which really struck Barthes – a texture that was familiar to him, that, in a Proustian moment, put him right back in Central Europe, where he'd travelled in the past. It was this transcendence that prompted him to say that the photograph was art: it *became* the thing it was depicting. This is, much like my encounter of the self-portrait of the young man, down to personal experience. Barthes related to the dirt road in the photograph because he'd travelled in a similar, perhaps the very same, geographic location. The familiarity, the striking of a chord in the observer, is what makes the photograph 'transcend itself', become real. The self-portrait

in the Groeninge Museum became transcendent to me because I found something in the painting to which I could relate – something fleeting, like scent or taste, but achingly familiar[h].

One class I sit for in Greenwich consists of an older group of artists. The class, as usual, takes place in a glorious studio, with soaring ceilings and high windows. It is a figure class, starting with a few short five or ten-minute standing poses, moving on to a forty-five minute pose, and ending with a long seated or reclining pose. There is one elderly, grizzled man in the class who always sits outside, smoking, when I arrive, and seems to be unable to sketch for more than thirty minutes before going outside for another roll-up. He looks doleful as a basset hound, with droopy jowls and dark under-eye circles. Something is wrong with his breathing, and I think he may have a hidden respirator to help, because his breath rasps quietly as we work. It reminds me of a cat I used to have, who snored in her sleep. It's quiet, consistent, rhythmic. His inhalation makes a small rattle, the exhalation, a small moan. I wonder if he is ill, for he certainly isn't well.

The rasping man always sits rather closer than the rest of the class. He always draws in pencil or charcoal, leaving a shedding of pencil shavings, eraser crumbs, and tobacco dust in a little cloud around his seat. But I notice, through all of the classes in which I pose nude, that he only ever draws my face. One in particular catches my attention. It is a pencil sketch of my face and hair; I'm looking up, into the distance. The man's pencil shavings and eraser crumbs rest on the paper like a cloudburst from my head, like a flock of birds viewed high in the air. It seems to capture my thoughts, swirling around me, whilst I sit. Near the end of class, he rolls up the sketches and goes outside for a cigarette.

'It's a strange sort of immortality, isn't it?' one lady asks me. 'All these pictures of you, ending up on walls in people's houses.'

I tell her how one painter I worked for piles all of her canvases on her back porch, never to look at them again. I imagine paintings, slowly mouldering, streaks forming in the damp, spiders spinning their webs across ears and cheeks. Dorian Gray's portrait turning to a corpse in the attic. A strange sort of immortality, indeed.

Marina Warner writes of 'a law of contemporary celebrity that replication, far from leaching aura from the original, magnifies it so richly that every copy grows numinous by contact with the original.'[iv]

Through this 'contemporary law,' may I then choose to think that I am not fragmenting myself, my image, into a thousand directions – fragmenting, and decaying – but rather enjoying a logarithmic, an exponential, immortality? May I be like some hardy plant, budding, dividing, and thriving across continents?

One version of me may be mouldering on a back porch in Holland, but another is hanging on someone's wall, having delighted the person so much that she purchased it from this or that painter. I am in Belgium, Sicily, Utah, and London. Am I thus prismatic, multitudinous?

Chapter Six

It's not true that I had nothing on. I had the radio on. [i]

I have spent a week being told I'm beautiful. How can one write this without sounding narcissistic? One probably can't. So what do I think? I think they do not see me the way I see myself. But they see me differently, one from another, as well. In that, I'm not saying whether I think I am beautiful or not: rather, I'm trying to think about it in an interesting way, beyond yes or no. If anything, I am changeable. Not eye-catchingly stunning, I can draw more or less attention to myself as I please, which is a freedom.

Until I was about twenty-five years old, I felt I could look pretty if I made an effort. Make-up, groomed hair, and a flattering dress would make me look 'cute,' possibly 'sexy' at best. If I wore my contact lenses rather than my spectacles, I'd look less 'dorky' and more 'normal'. I had a long stretch of feeling coltish and clumsy; I felt like a late bloomer. I was permanently bookish and liked unusual fashion that didn't pay much regard to my physical body, often wearing clothes a few sizes too big. I felt ungraceful, gangly, awkward. I would bump into doorframes and knock over glasses of wine at dinner. I still do. I have lived in my own world of books, history, science, for much of my life. My mother has always said, lovingly, that I was born in the wrong time period. I joke that I'm stuck in the 18th or 19th century. Perhaps that's why Bill recognises me in these portraits by the Old Masters.

Sitting at a tiny bistro table in Terrastje, a lovely little tavern

around the corner from the Atelier, I'm typing away, drinking an ale. My hair is in plaits and my large round specs slide down my nose. I feel I cut neither a picture of particular beauty or welcome. I often prefer to be left alone, and certainly don't want to be hit on, approached, or propositioned. I don't date.

That morning, as I was standing outside the bakery near my house, stuffing my face with fresh apple strudel, a fat, forty-something man smoking a cigarette invited me to have coffee at his house. I declined and hurried away. It was bewildering, that Continental come-on, the backwards flattery of attention from an unattractive person who was confident enough – or brash enough? – to ask. One of the difficulties is that, being originally from America, I find it hard to say 'no' without smiling. This is due to the completely irrational feeling that in rejecting an unwanted come-on, I'm the one being rude. Damn my American manners.

My spectacles act as a kind of shield; I'm stared at far less when I wear them. I look at the photo one of the students has taken of my pink-robed pose, and I'm not sure that what I see is beautiful. Classical, maybe. Elegant, yes. My skin is fantastically pale. I'm well-lit. My hair, which is in fact dry at the ends and needs a trim, looks glossy, dark, and wavy. My clavicles appear delicate.

I think my chin isn't so bad, but the flesh beneath my chin looks a bit paunchy: I've never liked it. My mother has always said I have my father's chin, that is to say, not much of a chin at all, or a poorly-defined one, which makes me self-conscious about it. My hands look large in relation to my head. My neutral expression seems flattened, strange. Yet a student and a friend separately say it reminds them of the Mona Lisa. I doubt she looked at her painting and thought her chin looked a bit paunchy. Indeed, I wonder if she looked at her painting at all.

The Mona Lisa is the painting everyone goes to look at, but

no one gets to see. It is a tourist's rite of passage to claim to have 'seen' the painting, but anyone who has fought crowds in the Louvre knows that the painting is always surrounded by tourists, stretching their phones and cameras out to snap a quick, grainy shot; that the ropes protecting the painting keep everyone so far back as to not properly see it, that there is no way one could stand and contemplate the work of art for a moment, let alone for any length of time in which one could really *see* it. It is probably the most-viewed painting in the world that no one gets to see; it has been killed by its fame. It is reproduced and referenced all the time. When we talk about my pose at the Atelier, a friend calls my expression a 'Mona Lisa smile'.

One can't maintain a smile for hours, even minutes, on end. Think of those awkward group, or family, photos where everyone waits and waits for the photographer to announce that he's done. The way the smile leaves the eyes before it leaves the mouth. This is why early photographs, where the sitter had to remain still for minutes on end, all look rather severe. A relaxed expression is a neutral expression. A smile is a form of communication, a flashing of teeth: the cousin of aggressive, territorial grimaces in apes. I've learned from Rob's portrait classes that it's the job of the painter to lightly touch something like a smile in at the very end, whilst chatting with the sitter – something Rob does so well it seems effortless. After two hours of stillness, he barely needs to say the word 'smile,' and my face relaxes, my eyes shine. A slight raise of the lip, a twinkle in the eye, and Rob's pastel portrait comes alive.

On my second day off after a week at the Atelier, I go out to dinner with my 20-year-old housemate from Amsterdam, Alacho. She is a particular type of beautiful, with pale skin and jet-black hair. There is an exotic, almost Egyptian slant to her eyes, and a steely Eastern European edge to her thick make-up and long black eyelashes.

She tells me how horrified she was when our landlady told her that a 'model from America' was coming to stay for a month.

'I thought you'd have big breasts,' she says, gesturing, 'and long, curly blonde hair, and my boyfriend was coming the same day you were arriving, and I was thinking, Oh my God…'

I burst out laughing. And think, how depressing – that this girl's image of 'American model' is *Jersey Shore*.

I sometimes wonder if people think, '*Her?* A model?' if the subject comes up. As an artist's model, I'm lucky to encounter gratitude for a natural appearance. Healthy, natural beauty should be celebrated far beyond the canvas. There's nothing a classical artist wants less than the fake, plastic look – I can't even write 'beauty' because bleached teeth and fake tans are so far from my aesthetic of beauty. I also know I never will be a fashion model. Once, I wrote to a lingerie company whose products I liked, and they asked for some photos. After I sent the photos, they never replied. I wonder what they thought. Did I seem bland? Fat? Downright ugly?

All of us are vulnerable to these worries, but overall, I am grateful for a healthy self-confidence. For better or worse, my curiosity overrides hesitancy. The new experience, in this case, modelling, proves more interesting than how I will appear within it – that bit doesn't matter very much. In life modelling, as in life, being healthy and comfortable is so much more important than being thin or beautiful. Artists often celebrate the natural body; it's wonderfully empowering. Artists not only want natural looks, they also love variety. Wrinkles, fleshy folds, grey hair – all are of interest, for the artist seeks humanity in all its guises.

Every day in the Atelier, one of the students murmurs, at least a few times, 'Beautiful. What a beautiful pose. What a beautiful model.'

Bill often says that the light, my pose, or simply I, look beautiful.

I try to give a little smile of acknowledgement without breaking the pose. I want to acknowledge the compliment but ignore it, too. Bronzed women at make-up counters the world over find me sickly and pale. Yet I fit the aesthetic of the Old Masters: pale skin, dark hair, hazel eyes, a straight nose and oval face. My skin has subtle changes in pinks, yellows, and whites, which can veer into violet, blue, or grey. Through chance, through bloodline, I fit the remit.

'Poor Kelley is going to become an object over the course of this,' Bill teases. 'We'll start calling her 'it'. Sometimes 'it' even breathes!'

What is beauty? Edward Dayes, author of *Essays on Painting*, writes:

'Many definitions of beauty have been attempted. Johnson calls it 'that assemblage of graces, or proportion of parts, which pleases the eye.' Locke, 'a certain composition of colour and figure, causing delight to the beholder.'[k]

Dayes goes on to say, 'The beauty of the naked requires several qualities to its perfection; as, that the form be in proportion, and well shaped; that it posses a free and easy motion, and be of a sound and fresh colour.'[l]

These definitions of beauty are Victorian, and delightfully unspecific. But they are acceptable, because, like a well-painted nose, these ill-defined 'definitions' sketch a blurry image, leaving an individual to fill in his own particular idea of perfection. I agree with Dayes, and yet what pleases my eye may not have pleased his.

When I go out for dinner with Alacho, I wear my contact lenses and, inspired by her aggressive fashion, put on heavier make-up than usual. The waiters in the restaurant speak to her in Dutch.

'He says, 'Your friend is beautiful,'' she tells me.

I nod my thanks; try to shrug off the compliment. I wonder how she feels. She is both more confident and more self-conscious than I was at twenty. She talks to me about how she kick-boxes for exercise; how she once punched a guy flat when he harassed her repeatedly in a bar. I'm very, very glad that she likes me. We'll become friends over the course of the month; she'll tell me her life story in a little-sister, unselfconscious yet utterly self-absorbed way, introduce me to jenever, Dutch flavoured gin, and take me to 'the cool places in town' (there seem to be two). I'm amazed by her self-sufficiency and shocked at the harsh treatment she's suffered from men both in Holland and the Netherlands. Is it cultural? Is it the crowd she runs with? Is it her dark, alluring beauty?

At dinner, Alacho looks stunning. She's wearing her usual style of clothing: four-inch stilettos, a skin-tight miniskirt, and a fitted top. I don't think I could physically function in such an outfit, not least because I couldn't walk in heels like that, but also because I would feel awfully exposed.

When I tell her why I'm in Bruges, she squeals, 'I couldn't sit naked in front of a bunch of strangers! I would feel so self-conscious!'

I begin to feel self-conscious, not from modelling, but from the attention I seem to be attracting when out and about on my own in Bruges. This is probably down to a cultural thing, but it does feel strange to travel to places – Italy, France, and apparently, Belgium, where it is acceptable for men to openly stare. Later, I buy a long, green plaid dress. I buy it because it is soft and comfortable. I buy it because the wind keeps blowing my short dress in awkward directions. I buy it because it buttons from calf to neck, and I hope that if I wear it with my round specs, maybe people will stop looking at me. Perhaps, because I am being looked at for my job, from morning till evening, I feel I have the right to *not* be looked at in my free time.

It isn't that I'm ungrateful for the praise; it isn't that I don't care how I look. Beauty opens doors: an attractive person and, particularly, a charismatic person, can network, persuade, and create opportunities for success. Of course, I feel lucky that people find me attractive, both in form and character, because it offers many opportunities. When I undertake a postgraduate degree sometime later, I will find myself quietly amazed that a great proportion of my classmates are beautiful, healthy, well-groomed young women. One friend points out that as tuition fees increase, it is, of course, the wealthy, well-groomed contingent that will continue to go to school; the educated legions will have good teeth because they can afford to have them.

I think of the notorious Amelie Gautreau. She became 'Madame X', renamed, in her portrait, by John Singer Sargent in an attempt to remove a direct reference to his model. But renaming the painting didn't stop the scandal: Gautreau was considered dressed in 'flagrantly insufficient' clothing, and both she and Sargent were humiliated by public criticism. Indeed, it marked the end of Sargent's career as a portrait painter in France, and he subsequently moved to London.

However, before the scandal, Gautreau was a *Parisienne*, a 'professional beauty' whose looks were said to stop traffic and cause riots as people tried to catch a glimpse of her. She was fantastically, unnaturally, famously pale, and it was later confirmed that she dusted herself with lavender-tinted rice powder to achieve the look[m] – though it didn't stop rumours that she ingested small amounts of arsenic to achieve an otherworldly glow. In the painting of 'Madame X,' her exposed ear is pink, giving away the natural tone of her unpowdered, naked skin.

In her dramatic account of the story of Madame X, Deborah Davis reveals how Gautreau never fully recovered from the scandal of the portrait, becoming a recluse in later life, banishing all mirrors from her home and dying in relative obscurity.

As Davis describes it, Gautreau became obsessed with the portrayal of her image and its public reception. She went from thinking that negative press was bad, to feeling that negative press was better than no press at all. No press, in the end, was what drove Gautreau to anonymity and, it seems, a kind of madness. The 'professional beauty' defined herself by her appearance alone. When it failed her, she had nothing left.

Sometimes I wonder – indeed, fear – that it isn't beauty, but neutrality, I offer. That somehow, I am the canvas, not the subject. Alexander Pope writes of this very dilemma, in *Of the Characters of Women*, which resonates:

> Nothing so true as what you once let fall,
> 'Most Women have no Characters at all.'
> Matter too soft a lasting mark to bear,
> And best distinguish'd by black, brown, or fair.

> How many pictures of one Nymph we view,
> All how unlike each other, all how true!
> Arcadia's Countess, here, in ermined pride,
> Is there, Pastora by a fountain side[n]…

As Pope says, women depicted in art can be malleable, wax-like, shape-shifting. The same model can pose as a Countess or any number of mythical incarnations. Many pictures of one woman can be so different from one another, but there is something in each that is still *her*. This makes for both a remarkable freedom, and a disturbing uncertainty. An ex used to say, 'I'm in love with the girl in your passport photo'. What about all the other photos of me? What about *me*? Of the many paintings and photos – 'all how unlike each other, all how true!'

In this way, I am like a courtesan or prostitute: the painter's hands turn me into whatever he wants me to be. Somehow, I become whatever the artists imagine. And I might disappear beneath all those eyes.

Chapter Seven

All that is important is this one moment in movement. [o]

THE NEXT DAY, Saturday, I have off and decide to spend it *moving*. Stopping at the bakery down the road, I order three slices of Gouda and choose a small round loaf dusted with flour.

Growing up, some of my favourite novels included *The Hobbit* and the *Redwall Abbey* series by Brian Jacques. I'd spend hours reading: reading, and eating – good practise for sedentary jobs (writing, editing, modelling). Thus, I have always been convinced that a proper adventure must be sustained only with a satchel full of bread and cheese. The apotheosis of adventure obviously consists of the hero heading into the wild on foot, or horseback, with said rustic snacks tucked safely into a worn leather bag. So, having found the perfect worn leather satchel in a shop the day before, I mount my squeaky bicycle (a rusty, rather than trusty, steed,) and head off along the flat path beside the Damse Vaart canal.

Tall poplar trees line the canal in straight rows on either side, the sunlight ticker-taping between them as I ride. The wind gusts through high, silvery leaves, sounding like a shell on the ear. Every once in awhile, packs of Lycra-clad cyclists spin by. Mostly, I am alone, save for the peeps, burbles, and mysterious bubbles rising from the long grasses on either side of the Damse Vaart. I catch glimpses of grebe, coot, cormorant, swan, mallard, and black-headed gull.

My guidebook has declared that a trip to Damme is a half-day excursion, but my cycle ride goes quickly, and I wander

around the charming whitewashed village in a matter of minutes. I settle on a bench in the old Herring Market, now a quiet cul-de-sac of residences. I thumb through my guidebook, finding it hard to believe that 28 million herring were processed here annually in the 15th century. The small square is empty, except for a white cat stalking a black bird.

I eat some bread and cheese, push my bike past rows of tiny cottages, admire the tower of the Church of Our Lady looming against a cloud-scudded sky. A few steps past the church and I realise I'm 'out of town'.

Not ready to head back into Bruges – it's barely noon – I cycle northeast along the canal. There is a cartoon image of fishing poles bobbing from the tall reeds on the bankside: I only see the men sitting with the fishing poles, each in his own small clearing, when I spin past. Some have umbrellas and wind-breaks set up to their west-facing sides. The cycling is easy; the wind is at my back. I remind myself I'll have to pedal into the wind when I head home, when I'm tired.

It feels good to move, to pedal, to gently rock my torso, to lean forward and straighten my back, flexing my arms. The straight, flat canal, with the straight, long rows of trees, creates a mesmerising optical effect. I pedal comfortably, humming a non-tune. Looking to the left or right – oh, the freedom of moving my head! – poplar trees create off-set waves in long, sweeping verticals. A tour group of thirty orange Vespas buzzes past, makes a loop across a bridge in the distance, and heads back along the road on the other side of the canal. Cows lounge nearby. Every once in awhile, I pass a dot of civilization: a café, inn, or small cluster of houses. I pass a house with an American aluminium letterbox ('aluminum mailbox') with 'US Mail' embossed into its side, planted on a stake in in the front garden, and feel an odd sense of time-warp. I ride all the way to the village of Sluis, in The Netherlands, inordinately proud for having cycled to another country, even though it is only ten miles from Bruges to Sluis.

I find a grocery store, and, staggered at how much cheaper prices are, fill the panniers on my bike. Struggling against the wind, I pedal slowly back to Bruges. My jeans are soggy from a bike seat that insists on holding rainwater, my backside is sore, my legs ache. It feels wonderfully free.

Chapter Eight

*So, if we may not let the Muse be free,
She will be bound with garlands of her own.* [p]

I'VE CHOSEN A splotch of paint to look at: a short, messy streak, on a bit of cardboard covering the lower part of the tall window. If I look at that straight on, my head is in the right place. After lunch, we move my chair, heaters, and blue backdrop to the other side of the room, chasing the north light. I borrow a paintbrush and daub a splotch on that cardboard in the window. A focal point on which I can never truly focus: without my specs, I see only a blur.

The blotches make me think of Virginia Woolf's short story, 'The Mark on the Wall.' Woolf describes 'a small round mark, black upon the white wall[q]'. At first she thinks the mark was 'made by a nail,' but she's 'not sure about it,' and later observes that 'in certain lights that mark on the wall seems actually to project from the wall. Nor is it entirely circular.' Woolf's narrator wanders from thought to thought, tangents and trails winding as naturally as any interior monologue. It is very like my experience of posing: like any experience of sitting quiet and still, allowing one's mind to drift, gently bumping up against ideas, turning them slowly over before setting them down and meandering to the next thought. Beach-combing along the shores of the mind.

One can picture Woolf lounging in her armchair, legs crossed, foot slowly bobbing, while a thread of smoke rises from a long, thin cigarette held loose between long, thin fingers, as she idly contemplates a mark on the wall.

And then, not idly, writes seven pages about it.

The story concludes with a charming surprise: the narrator is broken from her reverie, spiralling into a sleep-state (one can picture the long fingers, the cigarette, mostly ash now, drooping,) when a voice interrupts – 'I don't see why we should have a snail on our wall.'

The spell is broken; the mystery solved. I'll also learn how such a thing is plausible when I enjoy, for several months, the pleasure of having a working fireplace in London, and a tiny snail will slowly, silently escape from the waiting logs, and make its way up the wall of my own flat.

When I sit in the Atelier, my mind drifts: the paint splotch becomes a face, a tree, a geometric shape. I'll imagine my spot on the wall is a snail, too.

The ease of modelling depends on the pose. I've stood in positions where my weight isn't balanced correctly, and I can feel my foot and calf wobble and shake to a point where I wonder if I'll need to break the pose. I've had leg, arm, or foot fall asleep. One teacher set me up in a straight-backed pose with no back support and then seemed to completely forget about me. Nearly forty minutes later, she asked if I needed a break.

Usually, when I settle into a pose, the teacher asks, 'Are you comfortable?'

'I am right now,' or, 'Ask me in twenty minutes,' are my usual replies. It's very silly to think that if your model is comfortable 'right now,' she will be in forty minutes. Bill's method – 20-minute pose, 5-minute break – is just right. Even if I can hold a pose for an hour without complaining, the class in Bruges will run for an entire month. One must *move*. I'm astonished at how rarely the students get up to take a break. The best frequently step back from their work, looking at it from different angles.

Despite learning the ideal 20-minute sitting, 5-minute break pattern, when I return to London to model, I don't

enforce it. I should. Each teacher seems to have his or her own pattern, an idea of what works – whether it works for the teacher, the model, or the class, I'm not sure. Some seem to think a very long initial pose, up to forty-five minutes, is a good idea, with shorter poses ranging from twenty-five to thirty-five minutes. Some prefer a series of brief 'warm up' poses (a warm-up for the painters), and then a longer pose after a break.

I could simply bring in a timer and explain my system, and they probably wouldn't object. The little chirp of the timer is inarguable. Yet I don't, and I wonder why. Something in me is passive and eager to please. Indeed, it's a type of submissiveness that makes me pleased to meet the expectation of whomever is in charge, even if that expectation is unreasonable. Rather than bring in a timer and control the time, I'd rather sit for forty minutes and think about why I'm doing it.

When I speak to another model, she agrees that a baffling paralysis seems to come with the job.

'I've modelled to the point of *actually expiring*,' she exclaims.

She'd been in a simple standing pose and the next thing she knew, paramedics were waking her. Blood was running from her nose. She'd passed out, face-first, onto the floor.

'The worst thing,' she told me, 'was that of course I was naked.'

So what makes us stand there, up to, and beyond, our limits?

'It's about being *duty-bound*,' this model says. She tells me of a time she posed for an art class in an old warehouse, in wintertime.

'I was sitting there, staring at the *gaping apertures* through which the wind blew,' she described. 'It was positively Arctic ... I could see ice forming beneath the windows *on the inside of the building*. They had a single small fan heater. That's it.'

But she relishes these descriptions. Is it the romance? So

we do this for the sake of Art-with-a-capital-A? It reminded me of another model's story of posing for a sculpture class. She'd had an attack of food poisoning and had to run out of the room every 10 minutes or so to be sick.

Why? I asked. Why continue to model at all? What is the point at which we'll say, I'm not up for this?

'I knew a girl,' one of them tells me, 'who modelled for an artist who posed her with one arm reaching up, holding onto a bar. After hours of standing, she couldn't grip the bar anymore; her hand simply lost the ability to hold on. So he tied her hand to the bar. She had nerve damage for months afterwards. That's actual *torture*.'

Yet the model agreed to do it: it is a kind of complicity, a kind of madness.

Food poisoning would definitely put me off. The idea of being sick in front of everyone, or at least in a situation where they knew I was dashing off to be ill, and also being naked, is far too exposed for my comfort. If I think sneezing in the nude is weird, then a case of being sick is definitely out of bounds.

'It was too late to find a replacement,' she explained. 'They needed me.'

They needed her.

Something about being 'duty bound' is – physically, mentally – binding.

'Later,' she said, 'when I had the wherewithal to look around the room at the sculptures, there was shape after shape of me, twisted into a wretched, miserable, hunched pose.'

It sounds downright cruel. And why does no one in the class – not the teacher, not the students, say or do anything? I'd have sent the sick girl home.

'It's group passivity. Inertia.'

No one will act: something has to break the spell. Especially if the model doesn't speak up, no one will acknowledge there's something wrong.

In the case of the fainting-spell, it took everyone, the model included, by surprise. She'd had no warning, no feeling of dizziness. The students were all concerned for her, they called an ambulance, and the teacher wouldn't let her drive herself home after the class. So they did look after her. Blacking out on the floor was inarguable; it broke the passivity.

As for the poor girl with food poisoning – I'm astonished that she continued to model once she fell ill; it's outrageous that the class allowed her to do so. I suppose since she (stubbornly? bravely?) 'got on with it,' the class felt that it was acceptable to get on with their sculptures. Everyone was duty-bound.

Some models claim it is liberating to pose. I find it more of a satisfying restraint. I began modelling out of curiosity, and continue to model because it provides things to think about, and the time in which to think. When the Atelier got in touch, modelling provided some travel and adventure. There can be greater creativity within constraint; boundaries can act as a form of encouragement. Scaffolding and rules can allow us to come to new, unexpected ideas, 'greater heights'. One friend interested in the fetish scene says the same is true sexually.

The restraint of modelling is not a sexual pleasure, though sensory delight comes from the materials, the colours and scents of pastels and paint. Posing is mostly neutral, sometimes unpleasant. I haven't, like my colleagues, been pushed to my limits; I suppose I don't know just what those limits are, but I do not actively seek them. Sometimes I wonder why I keep going back. Then I enter a familiar studio, with a teacher I know, with lots of familiar, friendly faces greeting me, and the feeling of belonging pleases me. It gives me an identity that I'm able to contemplate, a stage set within which my role is 'the model'. It also gives me a feeling of belonging; I am part of this community. That, and unique time and space for reflection, are my reasons why.

As my interest in boundaries and how they can be challenged grows, a lesson isn't far off. Ideas of constraints and bondage crop up in my writing and creative projects, and these lead to my first experience of censorship: censorship that has to do with nudity.

I'd been travelling to Cambridge to run creative writing activities for the Whipple Museum of the History of Science, and on one of my Cambridge visits, found myself discussing bondage in literature with Dr. Joseph Crawford. Joe's work on 18th and 19th century literature focused on the Gothic. His writing made me wonder: in an age when the world was being mapped and measured, corseted by cords of latitude and stays of longitude, how must readers consider the Gothic novel? Is it to be treated as a shambolic, panicked response to exploration, or is it in fact a clever trap, a deliberately tangled web? These thoughts formed part of my introduction to the Whipple Museum's first art book: *The Rules of Form: Sonnets and Slide Rules*, which we produced as part of my writing residency there. Joe contributed a marvellous essay, referencing a poem by Keats: 'Fetter'd, in Spite of Pained Loveliness'. Joe's essay deals largely with that sonnet, with ideas of constraint and bondage: with the rules of form.

And what of the slide rules, in *Sonnets and Slide Rules*? The initial themes of measurement and constraint related to my wish to creatively interpret, in the form of poems and artwork, the neglected instruments of the Whipple Museum's mathematical cabinet. As well as inviting a handful of artists and writers to contribute their own thoughts on the theme, I wanted to hint that a slide rule may be more fun as a naughty toy than as a calculating device. I invited illustrator Badaude to create something around these ideas and, at the time, she was particularly interested in the literary movement of Oulipo. Taking a piece from the classic 18th century erotic novel *Fanny Hill*, Badaude put the extract through a translation-game which turned it from 18th-century pornography to a truly nonsensical piece of prose.

Despite the fact that Dr Crawford's essay included a full-length reproduction of the shackled, nude *Andromeda* painted by Gustave Doré, it was the short extract of text from *Fanny Hill* that sent the Museum into fits. They banned the *Fanny Hill* piece. I was astonished. One of their protests was that 'a child could open the book and read the pornographic content'. Surely a child could much more easily open the book and *see* at the lasciviously displayed naked figure of Andromeda, tied to a rock, her breasts thrust forward, on a full-colour page of the book? It's challenging (and hilarious) enough to interpret Cleland's descriptions as an adult, let alone as a child. Yet the painting was acceptable because 'anyone could go into the Fitz[William Museum] and see pictures like that [of Doré's]'. Surely, so too could anyone go into a bookshop and buy a copy of *Fanny Hill*? Yet the painting was allowed to be *art*, whereas the text was, without question, *pornography*.

This is the original excerpt:

'But now this visit of my soft, warm hand, in those so sensible parts, had put everything into such ungovernable fury, disdaining all further preluding, and taking advantage of my commodious posture, he made the storm fall where I scarce patiently expected, and where he was sure to lay it: presently, then, I felt the stiff intersection between the yielding, divided lips of the wound, now open for life; where the narrowness no longer put me to intolerable pain, and afforded my lover no more difficulty than what heightened his pleasure, in the strict embrace of that tender, warm sheath, round the instrument it was so delicately adjusted to, and which now cased home, so gorged me with pleasure, that it perfectly suffocated me and took away my breath; then the killing thrusts! The unnumbered kisses! every one of which was a joy inexpressible; and that joy lost in a crowd of yet greater blisses! But this was a disorder too violent in nature to last long: The vessels, so stirred and intensely heated, soon boiled over, and for that time put out the fire; mean-

while all this dalliance and disport had so far consumed the morning, that it became a kind of necessity to lay breakfast and dinner into one.'[т]

It was quite symbolic, having to replace the censored text with passive, if colourful, drawings of traditional slide rules. Revisiting this, I think that my failure as an editor was multi-faceted. I failed to justify the use of the piece, failed to defend it against the panicked response of the Museum. I failed to articulate relevant connections in the text to our themes in the art book. I was baffled by both the reaction the piece provoked and by the Oulipo-inspired wordplay being used. One might argue that the Oulipo piece created a deliberately tangled web that needed to be unraveled.

However, my discussions with Badaude about the censorship inspired her artwork for a different project, one that didn't have to bow to anyone's constraints. She happened to be designing scarves for a popular company at the time, and in one design, a row of beautiful, leggy women in sassy vintage lingerie, suspenders, and frills, stand showing off their backsides, surrounded by a frame of rulers – an explicit wink to the fun of spanking, à la Miss Hill, complete with mathematical instruments. Badaude named it 'The Kelley Scarf'.

One day, I'm wearing the scarf, and say to an older family friend, 'oh yes, my friend designed this: she named it after me.'

Of course, she wants to see the scarf. I untie it from my neck; unravel it.

'It's beautiful!' she says, looking at the scarf. '...Oh my, look at that ... ladies ... and rulers ... and rope ...' she trails off.

I blush furiously.

Chapter Nine

This Nymph, to the Destruction of Mankind,
Nourish'd two Locks, which graceful hung behind
In equal Curls, and well conspir'd to deck
With shining Ringlets her smooth Iv'ry Neck. [s]

DOMINATION, SUBMISSION; *being beholden to*: in no place is this more apparent than the bourgeois hair salon. For a long time, I availed myself of London's hairstylist academies, like Toni and Guy. For those with lots of time and little money, if you're willing to take a risk, it's great fun. I would come out after three hours and £5 with a funky new haircut and then leave it to grow out before doing the same again. One relinquishes oneself into the hands of a trainee hairdresser, but they, in turn, are in the hands of an expert stylist. I never had a bad experience, but then, I am not the type of person who cries if the cut is a bit shorter than anticipated. In fact, the only time I had a haircut I truly disliked was when I went to a supposedly posh salon, where someone razor-cut the ends of my hair and tried to give it the pin-straight look that I can only interpret as 'London Degenerate'. It was horrible.

Somehow, though, over time, I fall into the habit of frequenting not only a particular salon, but a particular stylist, in Blackheath. She cuts my hair in a way I like and trust, and I'm happy to put myself in her hands for an hour and know I'll come away feeling better for it. Yet there is a strange power play in the relationship that I can only guess comes from the training at any salon. This place is one of a chain that gently manipulates customers into believing that Everything Will

Be Perfect if You Use Their Products. They probably all do it. I'm amused that there is something slightly, differently, 'wrong' with my hair each time I visit and that, of course, there is an expensive product that will fix it.

I don't fall for it every time. When I do, I know exactly what's happening. It is the perfect psychological set-up: one enters the salon tired, rushed, and generally stressed with the grit and noise of urban life. One is gently taken into a peaceful space (one time when a harassed mother was there with a screaming child, one of the receptionists took the child outside,) and is given all sorts of things with ridiculous names, like the 'scalp ritual' and 'moisturising treatment,' and offered herbal tea, and lulled into a general state of complacency. Then, the sales pitch, veiled as friendly help: 'Have you ever considered colour? The grey is scattered throughout…' 'Your hair is feeling a bit dehydrated. Have I told you about our new hydrating treatment that will increase the moisture in your hair by 88%…' And so on… And one leaves the salon feeling, somehow, both younger and older, and about £100 poorer. A male friend assures me it is the same for men, but that a salon's biggest emotional manipulator is to threaten hair loss.

The past three or four visits to the salon leave me feeling like I have a lovely haircut, and yet I find myself growing unnaturally anxious. I feel frumpy, exhausted, and dowdy beside the sleek, black-clad creatures of indeterminate age that seemed to fill the salon. They all seem so young. Yet I sit in a chair talking about grey hair. 'I'm 28, for Christ's sake!' I want to cry.

Though I am the customer, ostensibly there for what I want, the person in charge is undoubtedly the stylist. I feel subject to her suggestions, and oddly attached. When I move house and there is a salon of the same chain much nearer to my new flat, I still make the trek to Blackheath to get my hair cut with her.

'I felt like I was *cheating on my stylist*,' one friend tells me,

about her own experience. 'And it was like she stood there and *watched me* get a bad haircut,' when a trainee had to fill in due to overbooking. 'As if she was saying, *you should have stuck with me.*'

This attachment seems to come from our vanity – the fear of a bad haircut – and also the comfort of seeing a familiar face. I like that, every two months or so, I'll see my stylist again. We know very little about each other, but the small talk we make over that hour feels like a bond. The social capabilities of stylists have always amazed me. My first paid job was as a receptionist in a hair salon. After several months I was fired for hiding in the back room, preferring to launder the towels than answer the phone. I couldn't bear to be chirpy and pleasant for such a protracted time.

Yet, on one of my visits, I am touched when my stylist is visibly nervous, not the cool expert I'm used to. 'I'm getting married,' she explains, telling me the wedding plans. I have no idea why she seems so anxious – to me, she appears beautiful, svelte, and clearly established in her profession. It's interesting to see another dimension, and not think of her as purely a creature in black that only inhabits this space of smoothing serums and hairdryers.

The next time I go to have a haircut, I make an effort to look good. It seems a bit silly, but as I'm not running from one meeting to another on that day, I take my time, dress all in black, and wonder if I will feel more like I fit into the environment. The change is remarkable. After the usual relaxing hair-wash and scalp massage, my stylist and I agree to try out a fringe, which we're both pleased with.

When she floats the suggestion of colouring my hair, I finally feel brave enough to say, 'I actually *like* it. The grey. I'm turning 29 this weekend, and I feel I've earned it.'

I think of everything I've been through over the past few years – several bereavements, a divorce, two house moves, and a classic romance-with-heartbreak.

My stylist is obviously surprised, but supportive. 'Wow,

29, what a great age to be,' she says wistfully.

'Well, I've heard your thirties are the best years,' I offer.

'Oh yes,' she answers, 'I made a lot of mistakes in my thirties, but I learned a lot. I had a great time.'

'I … would have guessed you were in your thirties…' I say, baffled.

'I'm 46!' she mock-whispers. 'But I married a 32 year old,' she adds, smiling.

We chat away after that, talking about age differences and couples, and how, in the right circumstances, with the right couple, age can matter not at all.

'But I've got to maintain myself, now,' she says, and that hint of worry tugs in her voice. 'He's *14 years* younger than me.'

Chapter Ten

My work is not about 'form follows function,' but 'form follows beauty' or, even better, 'form follows feminine.' [t]

One medium for modelling is photography. 'Fine art nude' is the phrase, which can include anything from elegant photos, classical or modern, taken by painters who want pieces to work from, to crap erotica. Normally, a model will ask to see examples of the photographer's work before she agrees to sit. It's easy to distinguish between styles, but the personality of the photographer is, initially, unknown territory.

The first time I work with a photographer, it's like going on an adventure with a friend. I've met an art student, a bit younger than myself, at a conference. She's a talented photographer. We chat about modelling, and she asks if I'd be interested in posing as part of a project she's completing on the subject of 'adversity'. She's travelling around the UK, working with people who consider themselves nudists for different reasons: people who find freedom in discarding their clothes in various contexts. We agree that I don't fit the remit exactly – I don't think I'm 'overcoming adversity' – but she needs one more subject for the project. Being a nude model is a variation on the theme.

One subject in her series likes to swim naked outdoors in the Peak District, while another prefers to be naked in the comfort of her own home, but considers herself a nudist. I've never considered myself a nudist, but I do choose to be a life model. I don't mind being naked; I do mind being cold.

I don't think I'm expressing a nudity-related urge when I model. I can just as easily not do it, and I pose for portrait as well as life classes. But I've never posed for a photographer and I'm curious, so I say yes to the project.

We scout out some sites in Greenwich for a possible shoot. It strikes me that I'd like to pose nude in a church. It's not to do with disrespecting a religious space; rather, I feel it would be appropriate to revisit the roots of a spiritual space by celebrating the female form. How many times is Mary depicted in a church, breasts exposed? Old churches are often glorious, architecturally, and would make a fascinating setting. But my photographer and I are too nervous about causing trouble, so we leave the church idea behind. We end up talking our way into one of the colleges where I often model, where I convince a reticent receptionist to let us use the studio for an hour, just before they lock the building up for summer break.

We fuss with easels and familiar paint-spattered cloths, arranging the beat-up, floral orange mattress I'm so used to sitting on. The moment of disrobing is a little bit unnerving to me: it's just the two of us in the room.

She moves in close and the lens snaps away. The camera can catch you a hundred times in a few moments. The big, clicking lens between me and the photographer – the artist – feels mechanical, and alien. It is more of an invasion into my personal space than portraiture. There is something cold about it, despite the warmth of the photographer herself, and I think of the commonplace myth, that the camera steals the soul[u].

I don't know how many photos she takes – possibly hundreds – but in the end, she sends me three. I'm nervous to look at them, in a way I'm not with paintings. This is about photographic artistry, but it's also me, bare, bared.

My favourite is at an angle: I'm curled on the mattress, on a brown striped cloth. I'm sitting up, looking high to the left, my legs tucked beneath me, with a cluster of empty easels

in the background, like a forest. Due to the angle – if it was a painting, it would be a foreshortening challenge – my left thigh and leg come forward in the image. There is a fold of flesh beneath my left breast; I'm bent slightly, left hand grasping left ankle. The huge studio windows glow in the background; pictures, sketches, and art posters decorate the walls. It's a familiar setting, an environment in which I pose frequently, but I've never had a picture of myself in it. I look curvy. I look real.

When I agree to model for a photographer at a later point, the mood is entirely different. He is assiduous: he has a contract for us both to sign, following the rules of the Registry of Artists' Models, saying he will not post any photos publicly without my permission. The fact that these are only 'for personal use', though, feels equally odd. He is an obese older man, who makes his way slowly up the stairs of the studio, leaning on a cane as he goes. We meet twice. He never gives an impression of being less than professional, but after the second photography session, I fail to get back in touch for a third, despite his interest.

It may be because the photos he – kindly – posts me after our first shoot are amateurish. It may be because the second time I model for him, we go through the same exact series of poses as the first time, like some kind of exercise programme. It may be because he shows me a portfolio of shots he's done in the past, all with beautiful young women, all in the same exact – quite neutral – poses. Stand forward: put right hand on left shoulder. Switch hands. Hands above head, right leg forward in a lunge. Lay on the ground, arms at sides, hair splayed out. There is an eerie, mechanistic quality to this repetition.

'People can justify anything, even – especially – to themselves,' a friend says when I tell him about the niggling discomfort I feel with this photographer. There is the obvious argument that this photographer's hobby justifies him getting close to young, naked women, when he otherwise

wouldn't. What bothers me more, though, is that the photographs aren't any good. There is a weird stasis in the pictures, which I don't want to be part of: it's unsettling to know that images of me have gone into his portfolio of young, nude females, all in the same static poses. There's something of the taxidermist about this photographer. It creeps me out, being part of his collection.

At one point, I ask him whether he ever submits his photos to competitions. He answers that he feels he's a long way from being good enough. I silently agree. But then, does he simply have a growing collection of nude photographs at home? I'm stuck: there is something lurid about the situation, and there is something sad, too. If he was interested in becoming a good photographer, he could photograph anything at all. 'Fine art nude' requires a nude model. And if he's interested in pornography, which I don't think he overtly is, there is plenty of graphic material available that doesn't require expensive camera equipment and studio hire.

He is concerned, to the point of nervousness, that I'm always comfortable. He constantly reminds me that if there is a pose I don't like, I should only say so. He particularly likes asking me to do 'bridge' yoga poses – back-bends – with my head towards the camera. I arch myself up in the air again and again.

'Not the same as life modelling, is it?' he asks.

'I think I'm out of practise,' I pant. My ribs are burning.

He verbalises how careful he is not to photograph my crotch. He won't say particular words: talks around them like a teenager. It is evident that, in his mind, what he's doing is acceptable because (maybe *only* because) he's not exposing my vulva. In art, breasts are all over the place, but a woman's vagina is still a source of discomfort. 'It's called a vulva; a vagina!' I want to shout. I don't.

'See?' He says, scrolling through photos on his camera. 'You can't see ... it ... here. I'd only want to take pictures of you that you'd be happy to show your mother.'

69

I wonder if this is more about what his own mother would think.

Despite his wariness about photographing my *mons veneris*, he is exuberantly fascinated with my breasts. Or, I should say, with breasts generally. He asks my permission to stand closer.

He murmurs to himself constantly, muttering about the camera, the equipment, the lighting, and about how excellent my breasts are.

Finally, bemused, I ask gently – afraid of inducing a stroke – if he'd mind telling me just what is so amazing about my breasts. I want to shout, 'for God's sake, man, they're just breasts!'

I don't.

'Um … can I … see them?' he asks. I try not to roll my eyes. He's been photographing me naked for the better part of two hours and has seen them plenty. I open my robe.

He looks. 'They're perfectly symmetrical, not too big, not too small. Perky.' He analyses with a technical remove, his voice flat. I close my robe.

He launches into a description about why photographers and painters prefer poses where the woman's arms are thrown over her head, because it 'lifts the nipples'.

One of the rare occasions that I am on the other side of a life drawing class – the artist side – I find myself drawing the soft curve of the model's breast, in charcoal, repeatedly, trying to get it just right on the paper. It's pleasant. Comforting. Maternal. I feel acutely self-conscious that I'm staring at the model's breasts: I find them beautiful. Like most people in a life drawing class, I avoid trying to draw her face beyond hinting at a vague oval – nothing personal. Though the breast is arguably more personal than the face.

Is it simply easier, as a beginner, to focus on the rounded curves of the hip, the back, and the chest? If that is justification, does it apply to photography? Is photographing a curve more pleasing than photographing an angle?

The Brazilian architect Oscar Niemeyer, who recently died at the impressive age of 104, found women's curves inspirational, even essential, to his designs. An article commemorating the architect reported that 'he famously once said the stylised swoops in his buildings were inspired by the curves of Brazilian women.'

'When you have a large space to conquer, the curve is the natural solution,' [Niemeyer] said. 'I once wrote a poem about the curve. The curve I find in the mountains of my country, in the sinuousness of its rivers, in the waves of the ocean and on the body of the beloved woman."[v]

Maternal, natural, like home: the curve is wherein comfort lies. Milton wrote of it:

So vary'd he, and of his tortuous train
Curl'd many a wanton wreath, in sight of Eve,
To lure her eye.[w]

Hogarth referenced it – the above quote is used as an epigraph to his *Analysis of Beauty*. He goes on to explain the challenge writers have faced through the ages in describing beauty, and says this is why *je ne sais quoi* has 'become a fashionable phrase for grace,' the ineffable element of beauty. But his *Analysis* is more than 150 pages long, trying to pin 'beauty' down. As for the allure of the curve, he writes, 'The eye hath this sort of enjoyment in winding walks, and serpentine rivers, and all sorts of objects, whose forms ... are composed principally of what, I call, the *waving* and *serpentine* lines.'[x]

It is the curve Niemeyer describes, 'the curve I find in the mountains of my country, in the sinuousness of its rivers'.

Did the memory of finding myself compelled to draw the curves of the life model help me to empathise with the photographer when I modelled for him? I'm afraid not. Working with him, I couldn't help but feel that his fixation with breasts was exasperating, even boring.

When, with great hesitation, he ventures, 'would you be ... willing to ... perk them up a bit?' I reply, after a pause, 'I think this reaches the limit of my comfort zone.'

'Of course,' he blusters, red-faced. 'I didn't think I should ask, but...'

But he did.

I was amazed to read, in model Kathleen Rooney's book, *Live Nude Girl*, that she had the exact same experience, in the States, with a male photographer. She never tells us whether or not she agreed to 'perk them up'. I said no. But looking back, it baffles me as to why this could possibly be an acceptable question, and further, a common one. It's tempting to think these men are disgusting, stupid, and degraded, but I think it may be something more mechanical. They are looking at shapes so intently that they forget there's a person attached. I do not, however, offer this as an excuse. If a photographer is asking you to perk up your tits, he's taken it well past the point of an artistic exercise.

Because this experience left me feeling strange, I sought an answer to the persistent question, 'why are breasts so fascinating [to men]?' (The answer 'sex!' seemed too easy, or perhaps boring, even if largely true.)

In art, at least, Kenneth Clark provides an answer. He writes that da Vinci studied 'the passage of light round a sphere,' that is, the phases of the moon. Da Vinci recommended that painters 'look at the faces of women in the mysterious illumination of twilight' in order to better understand 'the secrets of expression'. Clark says that da Vinci captures a 'delicate continuum of shadow and reflection,' which 'had its own sensuous beauty even before it was transferred from geometric spheres to the soft irregular sphere of the breast.' This brings us back to the sinuous, serpentine curve. Perhaps this hearkens to the temptation of the Snake in Eden – it had its own curvaceous, 'sensuous beauty'.

'Moreover,' Clark continues, 'light that passes gently along

a form, be it an old wall, a landscape, or a human body, produces an effect of physical enrichment not solely because of the fullness of texture it reveals but because it seems to pass over the surface like a stroking hand.[y]

Artfully rendered, the experience is tactile, sensory as well as sensuous. It makes us want to touch. The visual stimulus of light passing 'gently along a form' evokes a synesthetic response, an impulse for us to stroke the object. And this pleasure does not have to be, but can readily become, sexual. What is perhaps most pleasing and surprising about this analysis is that the origins of the pleasure, based on Clark's description, come initially, organically, not from the physical curve, which is both primal and feminine, but from our equally primal, equally feminine response to the shifting of light: the phases of the moon.

Chapter Eleven

...the serpentine line, as the human form ... hath the power of super-adding grace to beauty. [z]

'SOME OF THE students were really eager to paint your whole figure,' Bill explains in the second week, 'but there is enough nuance in your face alone to keep them occupied to the end of time.'

Lovely Bill, what a romantic – but we have until the end of the month, not the end of time. I can see that the more successful painters have an inherent patience. Several are overeager. They will need to learn not to rush if they want to improve.

Since we set the pose on the first day, the woman who runs the Atelier is obviously frustrated that I'm not posing nude. I've never felt more like a commodity: she clearly feels she isn't getting her money's worth. She asks me to do a photo shoot: a separate arrangement, paid separately. I agree. Many artists work from reference photos: it's not practical, or affordable, to work with a live model all the time. It's a special opportunity for these artists to spend the whole month in Bruges painting from life.

One bit of etiquette with shoots is for the photographer to send the model at least a few of the better shots. This woman never does. I feel like a piece of candy that a greedy child wants, and decide to let her have her candy: it's not worth an argument.

We meet after class for the shoot: the studio is empty but

for the two of us. I've packed a white dress that I wore on the first day, which she asked me to bring. We start with a series of nude poses. I twist and flex: it's all about the curve of the neck, the curve of the spine, the curve of the buttock, the curve of the calf. Even the arch of the foot. The drape of the fingers is important: anything flat, lifeless, is boring. There's a lot between 'elegantly curved' and 'crabbed and awkward'. I want to look balletic, not arthritic. It's back to Hogarth and his curves, his lines, which are anything but straight: he calls the waving line, 'as in flowers, and other forms of the ornamental kind … the line of beauty.'[aa]

This graceful curve of the fingers is something I learnt earlier in the year, at possibly my most dramatic photo shoot.

An Italian painter, Daniele Iozzia, writes to ask if I'll do a shoot in the British Museum. He sends me a photo of the style of dress he'd like me to wear, and offers to bring some costumes, but I have a good selection of dresses and take along a few of my own. I'm not sure what to expect. Has he got permission to do this? Are we allowed to just show up and start snapping? When we shyly greet each other at the Russell Street entrance, Daniele shrugs and says, 'If they ask us to leave, we will.'

Fortunately, the security staff at the British Museum don't seem to mind at all. I realise that everyone is snapping photos of everything: the huge marble sculptures aren't sensitive to a flash of light in the way that oil paintings are. This wouldn't be allowed in the Tate or the National Gallery.

There's something else I didn't consider: tourists. Hundreds of them.

And because I'm standing there in a long, strapless blue gown, with the lovely young scarf-wearing Italian dipping and turning and snapping away, asking me to raise one arm up, lean against the wall, toy with my hair, and so on – the hundreds of tourists seem to think it's a good idea to also take photos of *me*.

'Have you modelled for fashion?' Daniele asks as we

stand on a huge marble staircase. He asks me to thrust my hip and toss my hair like the nymph on the urn I'm leaning against. 'Do you know anyone at *Vogue*?' I joke. He doesn't, but insists I should contact them. As usual, I find this charming and absurd. I don't think myself anywhere near the otherworldly, oddly proportioned models – all of whom seem underfed and hardened to stone – in fashion magazines. I like food far too much for that sort of thing.

He hands me his scarf, explains the drape of the fingers. Nothing flat, nothing boring. There must be a flow, a graceful curve through the whole form. Daniele is only using a digital pocket-camera, but he knows how to work the light. Like Bill, Daniele knows how to find the magic angle: the high, soft, indirect, beam at just the right slant to the head, the shoulders. Anyone looking for a photographer should look for this: someone who knows how to work with natural light. It's the most flattering accessory of all.

A teacher in one of my regular life classes mentions that he always carries a small digital camera to capture shots of interest. He says that it's a challenge to decide what to translate to a painting – what elements of the picture are a 'photographic accident,' and therefore only work in the photographic medium. I ask if he considers himself a photographer. He says no, he considers himself a painter. I say that he has a painterly eye – is able, like Daniele, to frame a picture in a pleasing way. This is a question of translation: what works in one medium, but not another?

Another artist tells me his daughter hates photographs of herself. But when he secretly flips the image on the computer and then shows her that mirror image, she finds the picture agreeable. It is the 'her' she is familiar with: the person she is used to seeing in the mirror.

My first pet was a black cat with a white streak across one eye and part of her nose. When I occasionally saw her walk past a mirror, her face looked crooked, and as a child I won-

dered whether my cat always saw herself with a crooked face. Now I understand that my cat did not see her *self* at all, and thus did not go through life with some kind of image complex. These joys are the remit of humans.

The photo shoot at the Atelier takes a few hours. After the nude poses, I tie a white cloth on one shoulder, toga-like, and toy with a faux pink rose. One breast and part of my side and belly are exposed in a Grecian pastiche. Next, I get to wear a gorgeous silk Kimono from Japan, and I stretch on a rickety chaise picked up from an antique store. The challenge is to appear languid, when in fact every muscle is tense. None of the poses are, in reality, relaxed or comfortable. I twist and hold, hold and move, and she says, 'just there! No, back … there!' Hold.

I have to come up with poses I think are interesting, but she calls out, from her vantage point, what she thinks looks best. She's most interested in curves, and in the angle of the photo, which she'll try to translate into paint.

Next, I put on the white dress and collapse into what I hope looks like a graceful puddle on a woven red blanket on the floor. Then, we take a scarf and wrap it into a turban on my head, pinning a silky, thick red cloth around me, mocking up an 'Oriental' look. I chuckle as I hold a plain white Styrofoam ball delicately in my right hand.

'I'll make that an apple!' my photographer cries.

'Or a globe?' I suggest.

The faux-Eastern robes, the stand-in prop, make me rethink famous paintings. Art not for authenticity, but for aesthetic. The prop needn't be the final object. How many apples were never apples?

Bill explains that when working with a model one-to-one, the artist can break the pose into parts, only having her pose her hands when he's painting the hands, or purposely chatting with her in order to animate her face and therefore cap-

ture her expression, like Rob does in his pastel portraits. If just a single hand needs to be posed, the model can be reading in the meantime, holding the book with her other hand. Men can stand in for women, women for men; pillows can stand in for limbs or torsos beneath blankets. It's a carefully constructed illusion, the result of which should be more real than the thing itself – an unnerving thought when *you* are the thing itself. If foam balls can be apples, and men can be women, how many apples were never apples, and how many Eves were never Eves?

Chapter Twelve

Her hair, whose two black bands were so smooth they seemed each to be of a single piece, was divided down the middle of her head by a thin part that dipped slightly following the curve of her skull; and just barely revealing the lobes of her ears, it went on to merge into the back in an abundant chignon, with a wavy movement near the temples that the country doctor noticed for the first time in his life. [a][b]

ONE FRIEND FINDS it baffling that I could pose nude for the class at the Atelier and then go out to lunch, or travel to Ghent, or have dinner with them. Everyone saw me naked on the first day. Is it any easier for us to develop friendships, to chat and joke, because the pose I hold for the month is mostly clothed? I don't think so. There is a professional role to being nude in an art class that comes with unspoken boundaries and rules. The difficulty is that if they are unspoken, they may not always hold. A teacher in London once told me of a male model who would leave his clothes off for the entire class.

'He was a nudist,' the teacher told me, 'and it made the students so uncomfortable when he stayed naked during the tea break!'

So, here are some of my 'unwritten rules'.

The robe signifies my vulnerability or approachability at a given time. When the teacher calls a break, I tend not to make eye contact with anyone as I'm scooping up my spectacles and twirling my robe over my shoulders. As I tie the robe shut and step into my ballet slippers, I change from

object to person. I can talk to people; they can approach me. I can drink my tea, I can walk around the room and look at the paintings. I would not do this unclothed, as I would feel *naked*, awkward, and inappropriate. Being naked rather than nude is always down to context.

When I am nude, there is an invisible bubble around me. It is both personal space and a tangible temperature change – a bubble created by the heaters, cocooning me in a separate sphere. This is un-settled by someone walking past; the air swirls and I can feel a cool blast as this shell of air is broken, just for a moment. There is a slight tension when the teacher comes close to tape where I'm sitting, to mark where and how I'm sitting, because he or she is almost touching me. If the teacher has to move close, we don't make eye contact.

When I am nude, it is time to work: now we are concentrating, now the model is posing, now we are 'doing art.'

Usually, the teacher says, 'thank you, Kelley,' or, 'Thank you,' or, 'It's break time now,' and I nod, and put on my robe in a way that I hope is both graceful and unhurried. I do not want to give the impression that I'm uncomfortable when I'm nude, because I do not want the class to feel uncomfortable. But I'm nude for the sake of their painting, so to remain nude for longer than necessary feels uncomfortable – like the model who left his clothes off for the entire class time. That model was actually taking advantage of the opportunity to practise his nudism in a space that wasn't appropriate. Because of this wrong context, the art students felt, quite rightly, awkward. If he'd simply put a robe on in the break, it would have been fine.

No one should ever touch the model without her permission. Sometimes people approach, or, more frequently, ask – 'can you tuck your hair behind your ear?' 'Can you untuck your hair from behind your ear?' Students are far more likely to move my hand or hair if I'm clothed, cautiously approaching, asking, 'May I –?' Many of them take photos – again, if I'm clothed – so they can work on the painting af-

ter the class. Most of them ask if they can take a photo. They should always ask. Students do not photograph me, or ask to do so, if I'm nude. Is it too awkward, too invasive? Perhaps. The studio provides a special place to practise life drawing – drawing from life. At the best times, it can feel sacred.

In Bruges, I'm stretched on the chintz sofa after lunch, reading the latest translation of *Madame Bovary*. Laura comes into the lounge and glances over.

'What a great pose!' she cries. 'That would make a beautiful painting, with the light streaming in behind you. Would you mind if I took some pictures? I'd be happy to pay you for them.'

I've never been in this situation before. To think that on my lunch break, I'm still 'the model'. Laura and I work out a price we think is fair. She also sends me the photos later and promises to share pictures of the painting once it's complete. I'm glad she felt inspired to do a different painting – something modern and casual. But the exchange throws me into confusion about myself as a commodity. In London, I can't decide whether to ask for hourly rates for photo shoots, or much higher fees. Artists tend not to respond to the latter. I may be giving my time for an hour or two, but the painter will go on to create a lasting image of me, to sell. What does this mean? Whose image is it, and where does it go?

As Barthes argues: 'The disturbance (of photography) is ultimately one of ownership. Law has expressed it in its way: to whom does the photograph belong? Is landscape itself only a kind of loan made by the owner of the terrain?[ac]'

Surely I am the owner of my 'terrain'? But it's the role of the artist to create a saleable piece of art from the photograph. So is it only the model's *time* that she's giving? It seems fair and is, indeed, the norm for everyone to agree on an hourly fee. It is also good etiquette for the artist to send a selection of the photos he takes, plus a snapshot of the completed painting. Then, to continue the cycle of ownership, the model should keep these photographs for her portfolio

if she wants to, but it would be wrong to allow other artists to use those pictures. That particular image belongs to the artist who paid for the time in which to make it. It is a cycle of ownership borne of mutual respect for visual property. The sensible conclusion is to always ask.

I'm in Berlin, sitting in bustling Café Einstein with a friend, enjoying a glass of Prosecco. We sit quietly, foot-sore from a day of sightseeing. I idly follow the line of the many-paned windows up to the elegant gilt cornicing in the old Viennese-style room. A couple of women sit down at the table a few feet away. One has a large, professional-looking camera, and as I sip my drink and make some notes about the architecture, she turns and takes a few photos of me. It isn't subtle. I scribble on a cocktail napkin, 'the woman behind you is taking pictures of me'.

'Maybe you'll end up on some blog about European fashion,' my friend suggests. I feel both affront and curiosity. That was *my* image she 'took'! What will she do with it? I want her to know that I know she took my photo, but I do nothing. Has there become an impossibility of ownership in a world where every phone is mobile and most mobiles have cameras? In art classes, there is also the concern for privacy and property, which means I ask permission to take a photograph of anyone's work, even if the work is of me. Artists have strong preferences about whether they are happy for themselves or their work to be in a photo. One woman insists she would 'rather die than allow anyone outside of class to see an unfinished piece'. Then there are people who don't mind me taking pictures or putting them on my website. Some painters even give me pieces they've worked on that day.

When students want to take a photo of me in a clothed pose they are painting, I say yes. I think of it as one whole piece. There often isn't time to complete a work in class, and I think it's fair for students to be able to take a picture and

work on it later if they wish. Even though the class in Bruges is for a whole working month, many of the students still ask to take photos: they feel they haven't finished.

As the month wears on, tensions develop. In the morning group, one student always arrives late. Unfortunately, his easel is in a tight space between the other two students. He tends to show up just as the others have settled into their work. He has to either walk in front of, or squeeze behind, one student to reach his easel and chair. Then he sits, gets up, collects something he forgot, squeezes past, and sits, at least five times before settling. He jostles both of his companions, and asks to borrow materials – paint, or paper towels, or solvent. There is a silent, growing irritation pouring off of the scene in front of which I sit. I watch it spread. He seems entirely unaware of it.

Another challenge with this situation is that as we move into the next week of the class, the morning trio increasingly disagree about the precise angle at which I should hold my head. 'A bit to the left,' one says. Then, 'No, a bit to the right,' says another. It begins to drive us all to distraction. The second student to arrive always wants me to move a tiny bit. Then the first student, who has already begun to paint, seethes.

Finally, I call Bill over. He declares that somehow, everyone has moved too close together, and he makes us adjust. I pull my seat and backdrop a few feet back and all three students are made to sit much farther apart from one another. They are able to move *themselves* to hit on the right angle, rather than trying to move me. The late student doesn't have to distract the other two when he comes in at 10am. Now there is plenty of room to walk behind the chairs and easels. Everyone can breathe more freely.

The best example of the viewer's mistake that the 'wrong angle' is the sitter's fault is to watch tourists at the Leaning

Tower of Pisa. Visitors inevitably want a posed photo with their hands 'against' the Tower (which is far in the background) to look as if they're holding it up. When I was seventeen and travelling with friends, our tour guide pointed out with great exasperation that he'd seen a hundred people holding a camera and calling, 'no, a little to the left,' etc., when all one had to do was *move the damn camera.*

An amateur mistake for a painter to make is to stand up and critique a piece when he's been sitting. The teachers tend to make sure they are – even if they have to bend their knees, stand on tiptoe, or slouch in their chair – at the same height as the student. 'Let me sit in your chair,' or 'let me stand where you are standing' is a very important request. This is combined with the necessary swaying of the head, moving very slightly, shifting the gaze from object to canvas, back and forth.

'Just get comfortable with that metronomic rhythm,' Bill says, explaining how to compare the painting with my pose. Tick-tock: as swift, as rhythmic. 'You'll begin to see tiny, millimetre-differences, and then you can begin to correct them.'

When the students remember to look, and look, and look, something happens that I come to think of as a 'meerkat moment'. Unbeknownst to them, they will tick-tock, tick-tock, in unison, their heads moving slightly to me, to the painting, back to me, their glances darting, all in time.

One morning, I wake with a bug bite on my neck. Two of the students in the morning group have chosen this day to pull out binoculars. They sit about a metre away, yet raise the binoculars to scrutinise me. The bite – mosquitoes are vicious in Bruges – itches madly. I worry that it looks red and grotesque under the binoculars. I'm careful to wear the same light makeup each day: a patina of neutral brown-green eye shadow; a few swipes of black mascara; a dusting of powder to take the shine off my skin.

'Just look at the way the colour of her skin changes from her face to her neck,' Bill says, describing colour and tone to one of the afternoon students. It makes me break my silence.

'I have a bug bite on my neck!' I wail.

'Oh yes,' Bill teases, 'that ruins everything!' He chuckles and waves the comment away. This has been driving me mad all day, yet no one seems to have noticed it, not even those with binoculars.

In his 1805 *Essays on Painting*, Edward Dayes writes, *'painting is not the art of imitating Nature merely*, but requires the aid of reason in choosing the most perfect of her works, and rejecting her deformities.[ad]' This seems Victorian, but just as I edit myself, wearing concealer on the bite, the painters also edit their work. They choose what they see, or at least choose what to put down. Rejecting deformities, or realities, they are as vain about their images as I am about mine; we are all conspiring to make me look convincing, yet flawless.

When I model, students often say things like, 'I'm sorry for how I'm making you look,' 'You really are much more attractive!' or simply, 'It looks nothing like you.'

The difference lies in talent, of course: a painting can be skilled or amateurish, careful or sloppy, elegant or unrefined. The difference lies in whether the painter takes more time looking at their subject than at their canvas. Amateurs tend to look at their subject infrequently. They paint what they *think* they see. The difference lies in patience: allowing the painting time to develop, to go wrong, even to start over. And to paint what you actually see – which means learning how to see.

Students generally appreciate my efforts to be still and quiet, and to resume a pose as accurately as possible. Only once did I feel criticism directed towards me, but even then, I understood that it wasn't my fault. I was in a daytime class full of a mixture of retired women and younger mothers, with one flamboyant middle-aged man who talked through

much of the class. He was charming and funny, sharing recipes with us over lunch. But when everyone settled down to paint, he would start up a constant string of complaints.

'Oh, this is terrible!' [Sigh.] 'I just can't get this right.' [Huff.] 'She's so difficult!' [Etc.]

From my vantage point, the others didn't enjoy his monologue of whining, but no one said anything. (We were in England, after all.) The muted concentration that ideally descends on the studio was broken, his complaints rippling through the smooth silence – complaints that sounded like criticism about the model, as well as self-critique.

The following week, I needed to ask another model to fill in for me. She's a heavy, curvy girl, with hazelnut skin and tight, curly black hair. A lady we'd both modelled for once told me that this model is much more of a delight to paint, because she is more shapely and interesting than I am. Yet I was dismayed to learn that the man in the class had blathered exactly the same string of complaints – and had reduced this model to tears.

On the phone later, I assured her that it wasn't her body type or her modelling that was at fault. The truth was, he'd caught her at a weak moment. Despite knowing deep down the rule, 'it's not me, it's them,' she felt like she wasn't good enough. I was furious at the painter for making her feel that way, and at the teacher for not telling him to shut up.

It underlines another rule of modelling: a rule of courtesy and common sense. The man in the class wasn't criticising either of us, but by not reining in his personal difficulties and complaints, he made us feel inadequate. He didn't remember, or didn't care, that what he was painting had ears, feelings, and the capacity to take it personally.

Students will sometimes complain, in the abstract, that they would prefer to paint someone 'with wrinkles, and character'. My face is too smooth, my cheeks too plump: I'm not scarred or roughened or 'interesting'. I point out my grey hairs to no avail.

'She's still a baby,' Bill says. 'They say in Westerns, 'hold your fire till you see the whites of their eyes!' but if that was true, they'd never shoot.'

He explains that the 'whites' of my eyes are still blue-white. This becomes faintly yellowish with age. To a painter, even 'the whites of the eyes' are never white.

Physical characteristics that I see as flaws, people don't seem to see at all. I have a scar from falling off my bike when I was little. The split in my chin needed something like seventeen stitches. I can feel the scar with my fingers and, if the light is right, I can see it, but no one who has ever painted me seems to know it's there. There's a vertical furrow between my eyebrows, which I don't like. No one points it out or seems to notice it; it appears when I'm concentrating, frustrated, or animated. One day Laura finally says, 'do you see that line? I didn't see that before.' She decides to leave it out of her painting, and I'm glad. When, later, I mention it to one friend, he says, 'but I see it all the time when I look at you, it's part of you: I don't think it looks odd. It would be strange if it weren't there!'

Chapter Thirteen

The corners of the mouth are drawn downwards, which is so universally recognized as a sign of being out of spirits, that it is almost proverbial. [ae]

THE HALFWAY POINT in the month-long workshop in Bruges is a tough morning. I'm tired and achy. Each painter in the morning group is becoming frustrated with his or her painting, and feels stuck. One breaks down in tears. I begin to feel particularly sensitive, physically. I can feel each small muscle of my face and cheek as I wriggle my jaw back and forth. My head feels as if it is slowly tilting backwards. I begin to have grotesque visions of it tipping back and falling off, rolling away on the floor behind me. My lower back begins to ache and I can't get my feet to rest comfortably – they seem to shuffle, continuously, on their own. Because the whole class is painting me from my shoulders up, I can shift my leg position, but I don't want to fidget. I feel helpless against the ghostly two-step my feet are performing, just off the floor.

My hips feel crooked, and I think of my grandmother. As she aged, her pelvis see-sawed further and further off the horizontal. My mom said it was because Gran carried around five babies on the same hip over time. Eventually, Gran's spine was thrown off track, making one leg shorter than the other, and she collapsed in an agony of osteoporosis. She was bedridden when she died.

A wave of mortal terror, that at twenty-seven years old, I'm already feeling the beginnings of what will kill me, crashes

upon me. I feel like crying. In the break, I do as many yoga stretches as I can.

There is little worse for a model than posing when she's feeling bloated, achy, pre-menstrual, and spotty. The eyes of the binoculars exacerbate the feeling of hideous scrutiny. The two students who use them insist that it helps their accuracy. One day, these two, who seem competitive with their gadgets, pull out something I've never seen before: black mirrors.

This prop is called a Claude glass. Claude Lorrain was a landscape painter in the 17th century whose work had a famously gentle, 'mellow tinge'. Artists who wished to emulate Lorrain would attempt to attain the same softness by turning and viewing the scene through the tinted mirror, and painting what they saw there.

The students in front of me talk about their black mirrors and how helpful the mirrors can be, but pull out other, regular, mirrors as well. One explains that if she holds it vertically to her nose at the correct angle, she can see both me, and the painting, side-by-side at the same time, and so can compare the two images. A mirror held horizontally just above the eyes performs a different optical trick, making the model appear upside-down. Often, an artist will simply turn his canvas upside-down: many people say that it helps to see shapes rather than being distracted by the subject. Students are constantly squinting, or being reminded to squint, in order to see large shapes rather than being distracted by small, fine details. Picasso is probably the best example of one who broke the wholeness of a face and body into constituent shapes.

Despite all of these tricks to see the figure – large, small, vague or defined – they don't seem to notice emotion. Or I'm very good at hiding it. One morning, I have to go into the studio after having a gut-wrenching long-distance argument with a friend in London. I want to shout, or cry. I sit.

No one asks if anything is wrong. I'm wound up tight as a clock-spring, and have to keep unclenching my hands and jaw. The class paints as usual.

After class, I cycle away, and burst into tears.

A few days later, Laura joins me for lunch, and I mention something about having been upset. 'I thought there was something wrong,' she says. I'm relieved: she and I are growing closest, going out for hot chocolate and telling one another about our lives -- I tell her about my books, she tells me about her adventurous family and shares great recipes. It reassures me that at least someone who knows me a little bit could tell that things weren't right. I felt like I was wearing a neon hazard sign, but it seems no one would have said a thing. The role of a model, after all, is not to feel, but to be there: be silent, be still.

Chapter Fourteen

When I lie tangled in her hair,
 And fettered to her eye,
The Gods that wanton in the Air,
 Know no such Liberty. [af]

THE SILENCE OF the studio is broken by a growl.

'Your stomach's going to entertain us,' Laura teases.

My guts are especially chatty after lunch. Because I have nothing to do but think, I'm impossibly aware of my body, the rising feeling of hunger before lunch, the digestion and sleepiness after. Almost exactly twenty minutes after settling into my afternoon pose, keeping my eyes open becomes a total occupation. If I can struggle through fifteen minutes of tempting sleepiness, I feel fine again, but those fifteen minutes feel awfully long.

The only loud noise in the studio is the clatter, once in awhile, of a mahlstick. It's the first time I've ever seen or heard of this painter's tool. Bill uses one, and I suppose he required it as part of the students' kit, because he teaches some of them the technique, while others are clearly used to handling them.

The word 'mahlstick' comes from the Dutch 'maalstok' meaning 'painter's stick,' or possibly from 'malen,' meaning 'to paint'. Traditionally, a mahlstick is a stick with a soft padded head wrapped in leather or felt, though it can simply be a straight stick, or a cane with a crooked head: something to rest or hook against the canvas. The metre-long stick is for the painter to rest her hand upon, keeping it

off the canvas, particularly in fine work, and preventing the hand from smudging wet paint. The hand can shake when trying to do delicate work; the mahlstick steadies the hand. However, loosely held sticks regularly roll away and clatter to the ground, the crash ricocheting around the room, making us all jump. It helps to wake me up.

The most common noise that I notice my body making, particularly when I model nude, is stomach grumbling – *borborygmus*. I'm never sure – unless someone makes a joke about me being hungry – whether the class can hear. I'm extremely conscious of suppressing sneezes if possible, and I would find it torturously embarrassing to fart. A friend interested in drawing recently went to a life class for the first time and exclaimed how strange she found it, to observe the nude model sneezing. She said with surprise that bits and pieces move when you sneeze that you just don't see when someone has clothes on – this reinforced my own self-consciousness. It would break the façade of professionalism, of untouchable-ness, of being like a statue, to do something so human.

Yet it was a lesson to me to have a persistent cough one day when I sat for one of my regular classes in London. There's nothing worse for a cough than trying not to cough. It's like yawning: even thinking about it makes it hard to resist. I felt like I was choking to death in order not to disturb the class. I still don't know if everyone was being polite and ignoring my strange, curled up throat-clearing, or if they were concentrating and didn't really notice. How I longed for someone to say, 'take a break, take a drink.' Yet I could have asked, and didn't. I was back to being duty-bound.

I've read that male models can sometimes suffer – or experience – spontaneous erections. It is, understandably, awkward for everyone. In his book, *The Undressed Art: Why We Draw*, artist Peter Steinhart shares a story about a friend who ran the Palo Alto Models' Guild. Despite the man's experience and professionalism, Steinhart writes: 'The one time in

[the model's] career that he got aroused in the studio, he felt deeply humiliated. After it happened, he went to apologize to a woman who had been right in front of him, but as he approached her he saw that she had cheerfully drawn his erection, and drawn it beautifully. He was so embarrassed that he couldn't bring himself to speak to her.[ag']

The most dramatic physical response I suppose is visible on a woman is erect nipples, which can come from a chill just as easily as a saucy idea, and is something everyone can pretend to ignore. An unlikely but not impossible embarrassment would be if I bled, visibly, whilst sitting. A friend who went to art school told me about how one model always – *always* – had a tampon string hanging out between her legs. It's good manners to tuck it away if you're wearing one. We all speculated as to whether that model was trying to make a point, and if so, what, or if she just being sloppy. Be nude, we agreed, but be a lady.

Another friend wrote that she went to a life class where 'the model was a young starving artist from NYC with lots of tattoos, very professional, seemed experienced at modelling. Fact: I could **see** her clitoris. It protruded. She had pubic hair, but somehow her clit was big enough that it must have turned up in some people's drawings of her.'

My reply was that I'd feel awkward if I was so exposed, but then, I'm not shaped that way, whereas this model was clearly comfortable with her physique, which, as a model, is good. The model should be at ease so the artists can get on comfortably with their work – frustrations and discomforts should come from the challenge of the work, not from the model. The fact that my friend was overwhelmed by the girl's shape could have been similar to being overwhelmed by drawing a very fat or very thin person. Unless, I suppose, like the nudist model, this model was deliberately displaying herself sexually, to which I would say, exhibitionism, like nudism, doesn't belong in an art class. If the model was trying to make some other point, it was evidently missed.

But who are we to discern the intentions of others? I readily assume the people who draw and paint my nude form aren't there for sexual reasons, and perhaps that's naïve. And one might argue that I am indeed exhibiting myself.

Something I wonder on occasion, something that may only be evident to me, in my cocoon of heat and personal space, something that I would be mortified to ask anyone and so shall never know, is whether they can smell me. Sometimes an air heater is blowing hot air too close, and I feel sweat run down my side from my armpit. Yet this never smells of that overripe, oniony body odour of the Underground on a hot day: I shower and take great care with deodorant and lotion and perfume before modelling. I'm fastidious, more than I probably need to be. But sometimes I will be stretched on my side with my legs stacked, thighs pressed closely together, and when I move – uncross my legs, or stand to put on my robe – though I try to do so gracefully, sometimes I can smell that musky animal scent of me at certain times of the month. This both is and is not the smell of sex: not of arousal, but the suggestion towards it. It is *my sex*, or perhaps more accurately, *my life* – the productions and processes of my body. And I hope this smell does not creep into the room. I will give the outside: the skin, the coolness, the light; but the darkness, the warmth, this is for myself. When my scent threatens to float beyond that shell of air, I feel most exposed.

With spontaneous erections, exposed clitorises, and hard nipples, how is nude modelling about anything but sex?

'It would be naïve to think it's never sexual,' I say, as one teacher drives me back from a class to drop me off at the rail station. He's just told me that he explained to his class of ten sixteen-year-old young men, who are drawing a nude model for the first time, that 'it's not sexual'. He's apologising for the giggles that swept the classroom earlier. 'I think they're a very mature group and they're handling it very well,' he continues, 'but I made sure to speak with them ahead of

time. It isn't fair for the model to feel uncomfortable.'

I agreed, but I felt compelled to gently point out to this very nice tutor that it would have been foolish to think that each sixteen-year-old in that class was appraising me with pure artistic objectivity.

Indeed, in his much-referenced book about the nude in art, Kenneth Clark insists that 'no nude, however abstract, should fail to arouse in the spectator some vestige of erotic feeling, even although it be only the faintest shadow – and if it does not do so, it is bad art and false morals.[ah]' This seems to address a truth of human nature, to express a deep, honest understanding of how we see, for image *is* stimulus, and despite all our culture, we can't entirely leave our nature behind. Indeed, we should not, because passion and impulse are part of the joy of creating art.

Reading art history, one continually comes across quotes from John Ruskin, the famous critic of the Victorian era. Ruskin focuses on landscape, and when I think about his biographical details – the (false) story of his horror of discovering his wife had pubic hair and the (actual) non-consummation of their marriage; the fact that he was, by all accounts, a virgin – I can't help but feel it explains why I find his writing brilliant but bloodless. There isn't any fleshiness to it: it's like a dry sermon. Ruskin would have probably taken Clark's quote and said *any* erotic feeling would be bad, both morally and artistically.

This ties in to what has become a hot debate about Ruskin possibly burning erotic works by J.M.W. Turner, the great landscape painter. Ian Warrell makes a good case for where this half-truth stands in *Turner's Secret Sketches*, a book that reproduces a number of the images, which had supposedly been burnt. One thing I was curious about in regards to these sketches and watercolours is where the distinction falls between 'nude' and 'erotic'. Many of the pictures are from Turner's European travels, but, Warrell writes, 'As well as studies of the female nude, this [sketch]book is interesting

in showing the interior of the Life Class itself, with the relationship of the young female model to those who scrutinise her. As in some of his earlier studies from the life model, Turner managed to make furtive observations of the model's private parts.'[ai]

The discussions around Turner's erotica are difficult: 'A ... problem is that much of the discussion has been limited by being set within the judgemental framework of Victorian values, as if the production of doodles of frankly sexual character mark Turner out as some kind of pervert, whose actions have to be subjected to psychological analysis in order to be excused ... as Peter Webb has written, for many artists the production of erotica was 'merely a normal part of artistic development.'[aj]'

Looking at the sketches and unfinished images from the model's point of view conjures mixed feelings: it seems an intrusion to use a life class for erotic forays; for example, Turner seems to go off on tangents and sketch the act of penetration: perhaps this image, more than his others, demonstrates an erotically preoccupied mind. Is it any better for him to draw scenes of copulation on his travels, where he was evidently drawing intimate acts in brothels, as well as from his imagination? Is a painting of [Warrell suggests] Turner's companion Sophia Booth, legs spread wide in a presumably voluntary pose, more acceptable than a focus on the life model's 'private parts'?

From a modern model's perspective, I think it is. It seems that the mores of the time, whilst allowing life drawing, demanded a respect and distance towards their model as much, if not more, than is practised today. Warrell notes that 'Turner was a regular visitor to the Life Class at the Royal Academy throughout his working life, making his first studies of the female nude around 1795, as soon as he reached the permitted age to draw from naked women.[ak]' This would have meant Turner was twenty: at least four years older than the young men drawing me in their first life class.

Though I do not always see what people draw, I would indeed feel a sense of violation if I noticed close studies of my *pudenda* (Ruskin's preferred term, though one expects he preferred not to say it at all,) as Turner has made from some of his life class sketchbooks. And if he'd had the choice to keep these drawings of 'private parts' private, it wouldn't be a public debate now. Maybe it is unfair of us to consider this. Maybe, as Lady Eastlake, whose husband was Director of the National Gallery and President of the Royal Academy, wrote in 1862, 'Turner's professional character is, of course, public property, as the literary character of an author is. But to pry into the private conduct of a man just dead … conduct … which, if faulty, he had the decency to hide … is something which cannot be too severely reprobated.[al]'

Much of Turner's 'erotic' drawings seem to be 'just' nudes. There are some instances of copulation and other sexual acts that tip the scales to the erotic. I wouldn't be surprised if many authors try their hand at writing erotica, just as many artists must sometimes paint or sketch sexual scenes: exploring this is part of our development as sexual entities. It is a rare specimen who does not develop an interest in sex. I've tried to write erotic short stories which won't see the light of day not because of the genre, but because they are rubbish. Many of Turner's erotic sketches aren't very good technically. It is practise, for the skill and for the imagination.

It would be foolish of me to think erotic thoughts never happen when I display my unclothed figure to a room full of people. That said, the wildest come-on I've ever had is a sweet old man asking, 'Will you run away with me?' in a joking tone. And he only said it to me at the end of class, once I had put my clothes back on.

Though it would be 'bad art and false morals' to deny passion in painting, Clark also writes, 'it is widely supposed that the naked human body is in itself an object upon which the eye dwells with pleasure and which we are glad to see depicted. But anyone who has frequented art schools and

seen the shapeless, pitiful model which the students are industriously drawing will know that this is an illusion.[am'] I can only object, and conclude that Clark was unlucky with his models. The women I know (I don't personally know any male models,) are neither shapeless nor pitiful. Though he found his models uninspiring, Clark admits that 'it is from the rapturous scrutiny of passion that ideal beauty is born.[an']

It seems that those nearest to the nude model – the teacher especially, and the students next – work to stamp down ideas of sexual attractiveness, whereas friends I speak to who aren't involved in life drawing have no hesitation in commenting about 'trouser tents' and how 'you must be their dream come true!' when I tell them I'm sitting for these young students.

I'm also amused and slightly anxious that this art class full of young men, who are certainly not going to be thinking about sex, has inspired the teacher to set me up lying flat on a long, high table. 'We're going to work on foreshortening,' he explains. Foreshortening – an optical illusion making an object look like it is coming forward at the viewer – is extremely difficult: too ambitious, I would say, for students working from the figure for the first time.

The pose also has uncanny echoes of artworks I've recently studied for a different book – those of the female form laid out on a bed, operating, or dissecting table, as in Enrique Simonet's 1890 painting, *Anatomy of the Heart*, or Edvard Munch's 1894 piece, *The Day After*. Both women – dead, or at least in the case of the latter, unconscious – are laid flat, with vulnerably tilted heads, exposed throats, and limp, draping arms. Beautiful – and utterly exposed.

I sit up on the table, wrapped in my robe, as the teacher finishes his short lecture to the class. I'm grateful to slip off my spectacles – the room, and all the boys in it, become a blur.

'Oh, by the way,' he adds as I shrug my robe from my shoulders, 'this is Kelley.'

'Hi!' I say. Stretched on a high table, naked, pale, and smiling, I wave to the class. I swallow a burst of laughter.

Dead silence.

They boys do get on with their work, of course – these pieces are for a portfolio that is academically important, and so they have an incentive to focus. There is some goofing around when they drop pencils or swap iPods. But overall, the concentration in the room is that of most art classes and some of the students are incredibly accomplished. Despite teasing from my own friends – I am still surprised at the quiet friend who said 'you must be a dream come true!' – I try to switch off any concerns or curiosities about what the boys might say about me, the model, after class. It's best to assume that they needn't think about or discuss me at all. And I'm charmed when, after the second class, one of the quiet boys strikes up a conversation with me. The class is wrapping up, and I'm wrapped too, fully clothed. He asks about my poetry, and walks me to the bus stop, telling me about his own poetic ambitions. How pleasing that, after all, we can be ourselves – but perhaps it's easier when we're dressed.

In this work, sexual frisson has twice seemed a possibility. The teacher of one class was working on a new portfolio and asked if I'd sit privately for him. I've worked with him for a few years in one of my regular classes. He's my age, very good-looking, very friendly. As I reclined in an armchair a few feet away while he busily sketched, I couldn't help but think that here we were, a young attractive female and a young attractive male, I sitting without clothes, he focusing intently on my body. It had the potential to be sexy. Yet as he worked, we chatted; he told me about his upcoming wedding, I told him about my upcoming holiday. Would it have been embarrassing if he'd known I found him attractive? Did it matter if either of us found the other attractive? Did the dynamic work more effectively if we did? He's the artist I most enjoy working with, because we know each other well,

the setting and the people are familiar – we get many regulars in the class – and I've even modelled for a portrait class in which the other model was his wife, and I like her just as much. If we lived nearer, I would think we'd be friends.

Some friends who attend other life-drawing classes, though, are not comfortable with the idea of me ever modelling for them. I don't see it as a conflict. In the hugeness of London, it isn't likely to become an issue – occasionally I see someone I think I recognise and I think they must be from an art class in which I've modelled. As being an artists' model is only a segment of my life, as I have other personae as a poet, writer, and teacher, I joke that I'm like Clark Kent – I go into a telephone booth and take my clothes off.

The second time the job got sexy, but didn't, was when I made my way to a studio in Fulham to meet a photographer whom I thought was female. Nicola turned out to be a dark-haired, lean, stunning young Italian man, with a tenuous grasp of English. He made it a point to explain, more than once, that the mural-sized portrait against the far wall of his studio was of his girlfriend. He encouraged me, after a round of photographs and an espresso, to 'be more confident'. It made me wonder if I wasn't being bold enough with the attitude of my poses because I felt shy in the face of *his* beauty. Or, perhaps, shy in the looming, gorgeous-yet-asexual face of his girlfriend?

In the photo he sent me afterwards, I'm perched on the bench in front of the window, whitely luminous, lithe. It's my favourite nude photo – and I hardly recognise myself. Maybe Nicola's beauty rubbed off on me: maybe the espresso, or his encouragement, inspired the confidence he wanted.

Meanwhile, Bill, 70 years old and a proud advocate of only working with beautiful women, whether his apprentices, his models, or his wife, gets closer to me than any other painter, and it's utterly harmless.

It is the last day of the third week of the month-long course. Bill pulls up a chair right in front of me, a little off to the side, and settles into it with a clean paintbrush in his hand. He's so close that our knees interlock.

'Make sure I'm not casting any shadows, now,' he says to the student he's instructing. He launches into a precise, slow explanation of the points of light on my face. He begins with my nose, brushing along the bridge as he talks. I giggle: it tickles. He's patient. I regain composure, and he continues.

I don't flinch when he gently slides the brush up the side of my nose, stopping short at the inside corner of my eye, explaining those points of light.

'What a trouper!' he says.

The student carefully puts in tiny daubs of white mixed with alizarin crimson and yellow ochre. 'Just one, maybe two dabs, not even a stroke,' Bill cautions.

There are points of light at the peaks of my eyebrows; the two ridges of my upper lip, my chin. The brush gently points out each spot. It is intensely intimate, intensely focused. I trust Bill; he can sit in front of me so closely, lean in, take the clean brush, and 'paint' me with no discomfort, and his jolly reassurance that he won't poke my eye out. I hold perfectly still, hardly breathing.

'You are just so beautiful to look at!' Bill says, leaning back in his chair. 'You sit so still. It's so wonderful to look at someone who isn't moving. I just love how pale you are. You have wonderful colours, just wonderful.' He falls silent, looking.

More points of light at the indentations where my nose becomes my cheek and beneath my lower eyelids: more brushstrokes.

His compliments are for me, and not for me. Bill has learned to see a person intently, broken down into points of colour and light. 'It is not the thing you are seeing, but the light on the thing,' he repeats, again and again. Yes, I am still; yes, I am pale and pink and 'Northern European' in

tone. But he is not so fascinated by my beauty as the beauty one can learn to see in the human face. He is seeing the light on the thing, and I am the thing, and the scene is exceedingly peaceful.

Bill's calm, grounding presence doesn't, unfortunately, influence everyone in the class.

It's lunch break at the Atelier and I'm sitting on the faded chintz sofa reading *Jane Eyre*, bent over my plastic container of salad. I'm wearing an ankle-length white skirt and an ancient button-up cardigan with beaded flowers on the front. My hair is in a ponytail; my round spectacles slide down my nose.

'You're so geeky!' one of the students cries. 'You're like a librarian in here, but in there you're so beautiful and sexy.'

I don't have a response.

Without my accoutrements, stripped down to just a robe, or to nothing at all, I'm perceived differently. I don't even recognise myself. *That* is the illusion, not this façade of clothes or accessories I wear.

Chapter Fifteen

High there, how he rung upon the rein of a wimpling wing
In his ecstasy! then off, off forth on swing,
 As a skate's heel sweeps smooth on a bow-bend: the hurl and gliding
 Rebuffed the big wind. [ao]

A FEW OF us from the studio travel to Ghent on a day off. One thing we want to see is the famous Ghent Altarpiece. Completed in 1432 by Jan van Eyck, known as *The Adoration of the Lamb*, or *The Mystic Lamb*, it is, as Andrew Graham-Dixon says, 'the most radiant Flemish masterpiece of the lot.[ap']

The altarpiece is a 24-panelled polyptych depicting complex biblical scenes. As in other van Eyck paintings I've seen throughout the month, I especially admire his depiction of cloth. The Virgin's sumptuous blue robe has the texture of velvet; the reds glow. I've become interested in drapery and folds since the last photo shoot, in part because it is a challenge to work with cloth, to drape it in an aesthetically pleasing manner over the body. The thickness, weight, material, and texture of the cloth all influence its look. How to paint *weight* or *density*?

A modern, comprehensive audio guide accompanies the altarpiece[aq]. The guide suggests that the back panels depicting the Annunciation may show van Eyck's room, with a view overlooking his street in Ghent. Maybe van Eyck painted the view he saw from his own window. The appropriate footwork was done, and a plaque affixed to the building in which the studio might have existed.

Van Eyck's imagination and his ability to render it visible makes the Altarpiece a masterpiece: a flock of angels have the wings of tropical birds, including one with peacock-feathers. Figures who, in the Bible, were all meant to be wearing white are draped in royal red, green, and blue robes. The nude Adam and Eve figures, though they look awkward and out of proportion, are depicted with striking realism for the time: Graham-Dixon describes it as a 'tremendous lack of idealism: these are real human bodies. And that's the whole point: because it is their sin that has condemned us to live in the world of mortal time...[ar']

The panel I enjoy most depicts a still life of a towel hanging on a wooden pole: a calm, quiet break from the bustle and glory of most of the altarpiece. There are no people in the panel: just a towel. I like to think that it was van Eyck's towel, hanging in his room. Perhaps he was tired of fantasies; perhaps he wanted something of himself in the painting. The Belgian room grounds the piece in time and place. It captures a moment of quiet in an otherwise busy world – whether the world of the Bible, or van Eyck's own time, when he might have looked down from his studio to the busy street below, with horses and street hawkers and merchants. The artist has the power to step back from that world, helps us frame it, and holds it at bay.

'The first people who saw this picture were so stunned by it, so taken aback by it, they could not believe that an image made of nothing but paint applied to boards of wood could seem to them like life itself,' continues Graham-Dixon. 'So much so, that the rumour was put about that this painter wasn't just an artist. He was a magician. Some kind of ... necromancer.'

Part of me wishes we were at the beginning of this revolution in art; wishes we weren't steeped in hundreds of years of history and skill, sparked by van Eyck. Part of me wishes that it would be more than an historical experience, more than an exercise of privilege and education, to view such

painting as this. For Bill, it is a spiritual experience, a pilgrimage – he follows in the path of these great painters; he paints pictures that are unbelievably lifelike. I'm honoured to be part of this tradition, yet the paradox is that I can never be outside it. I can never be as amazed as the first people to see these paintings. I have seen too much. I am too aware of the history into which these paintings fit. So, the magic I see must be of a different kind.

We step out of the church into Ghent, to wander the streets van Eyck looked upon while painting his altarpiece. The flickering crystalline light is the West Flanders light in which he painted. The late sunsets, the bright evenings, allowed him to work long days. The very brightness which keeps some of us up late at night, our circadian rhythms thrown off by persistent daylight, allowed peacock-winged angels, robes, pearls, and a very real towel to be painted into being.

Back in London, I'm reading about 'the vexed issue of the condition of [Thomas] Girtin's works today and the degree to which they have faded.[as'] I'm looking up Girtin, a watercolour painter, because of a phrase I've been hearing, associated with many paintings: 'fugitive colours'. It's enchanting, as if certain pigments have gone on the run. In a way, they have.

Edward Dayes, Girtin's mentor, wrote, 'It is much to be lamented, that the most beautiful colours soonest perish; therefore, the student had better sacrifice brilliancy to permanency.[at'] Yet, despite Dayes's understanding of fugitive pigments, that 'vegetable colours are the first to fade,' and despite Girtin almost certainly being taught that knowledge as Dayes's student, he wilfully painted with 'indigo, lake, gamboge, yellow lake, and brown pink, [which are] all highly fugitive when exposed to light.[au']

Why did Girtin insist on using pigments that would certainly fade, the greens and blues sighing away into a monochrome of reddish-brown? *Morpeth Bridge* (c.1801), a pastoral scene showing trees, cows drinking along a river bank, and

the eponymous bridge reflected in the calm waters, shows 'small areas ... protected by a mount thus providing evidence of its original appearance and the degree to which the colours have been affected.[av]' Was Girtin 'at best negligent, at worst irresponsible[aw]'? Or, as another critic writes, did he subscribe to a 'culture of pictorial evanescence[ax]'?

It is the latter which particularly captivates me, flying in the face of our prevailing – though false – insistence on permanency, our waltz-step around the inevitable. We work so hard to make things last, putting energy into the entropy surrounding us. It is joyous that Girtin did not sacrifice brilliancy for permanence. He painted pictures as he wanted to, when he wanted to. Despite his mentor's insistence that 'the most beautiful colours soonest perish,' Girtin painted with them anyway, because there, for the time he was painting, he was painting in the most beautiful colours he could use.

Girtin's work leads me to think of Jack Gilbert's poem, 'Failing and Flying'. It explores our assumptions of failure: specifically, that a marriage is deemed a failure if it ends in divorce. I read the poem whilst going through a quiet divorce. A wise friend said, 'it's not a failure; it would have been a failure to remain in the marriage if you weren't happy'. The marriage needed to end, but it was largely a positive experience, one I don't regret. Like Girtin, my husband and I did not sacrifice brilliancy for permanence.

Gilbert's poem begins, 'Everyone forgets that Icarus also flew,' and ends, 'I believe Icarus was not failing as he fell, but just coming to the end of his triumph.' Viewing Girtin's watercolours, I love considering his past triumph, the flight that I've missed: what was once there is there no longer. Perhaps some of the criticism comes from the fact that Girtin didn't follow the rules: that he failed in his technique. But perhaps some of the criticism comes from the envy that we cannot see the power of what was once there: we are left only to imagine it.

Reading about pigments makes me wonder about my palette: of what colours am I made? I write to a few artists, and their replies read like alchemical shopping lists. Bill's oil palette lists ivory black, white lead, transparent earth red, raw umber, yellow ochre, cadmium red light, alizarin crimson and ultramarine blue. Rob's pastel palette lists cadmium yellow, cadmium red, yellow ochre, raw sienna, alizarin crimson, ultramarine blue, burnt sienna, and titanium white. His son Joel, who works in London, tells me that his father's palette comes from painting in South Africa, but Joel 'tried using this palette to paint English light and people, and the results are always too warm.' I recall that Rob uses his pastels on warm, brown paper.

These answers are the general palette each artist uses, but it is impossible to measure just how much alizarin crimson goes into my portrait, or the portrait of another. Not only does it vary from person to person, but from day to day, from light to light, from mood to mood. The names are pleasing, though: the chemistry of a portrait. Just as we know that our building blocks are 'A, T, C, G,' (adenine, thymine, cytosine, and guanine make up the base pairs of DNA,) I also feel, in naming ultramarine blue and burnt sienna, raw umber and transparent earth red, that it helps me come a little bit closer to understanding how I am built. 'Built,' in this case, in paint. Bill said that the students would reach a 'molecular level,' not through a laboratory or my DNA, but through a paintbrush and the pigments mixed with it. Whether chemistry, art, or the chemistry of art, it will all eventually break down and fade away.

Chapter Seventeen

Maybe there is a beast ... maybe it's only us. [ay]

ON OCCASION, I go to a spa for a massage. Though this relates to modelling – I can get stiff and sore when I pose – it's also, usually, a pleasure. I went to The Porchester for a day of relaxation and found myself in a time warp. The grand architecture displays all the shabbiness of a building that was opened in 1929 but hasn't been updated since. It is an Art Deco hammam with high vaulted ceilings of pressed metal, green and white tiling, and swirling staircases leading into bowels of steam.

The Porchester is more a 'leisure centre' than a posh spa, and its entry price reflects this. It also meant that at 11am on a Wednesday, during one of the 'female only' sessions, the spa was very quiet.

Through the main door – glass inlaid above with dust-covered gold letters spelling out 'The Spa' – I came to a dark wood-panelled booth and, feeling like I was entering a hotel Bertie Wooster might have frequented, I paid the entrance fee. I was given two clean, white, stiff towels and directed through a set of double doors, where an older, swarthy woman, wearing orange lipstick that had migrated to the outer edges of her mouth, instructed me to change in a cubicle and put my belongings into a locker, which swallowed a 20p coin. There were three changing cubicles. Banging my elbows against the walls of the narrow space, I changed into my bikini and wrapped myself in a towel as instructed.

The large, square room had a very high ceiling. The walls

were lined with wooden loungers, each with a vinyl green mattress. Old lockers lined parts of the walls, and at regular intervals there were small, wooden-framed mirrors with little shelves, as if spa-goers could each have their own vanity table, though realistically these were very hard to get to, as they were affixed to the wall behind the lounge chairs. One large mirror lined the back wall, with hairdryers, and this was where one actually seemed able to dry one's hair or apply make-up.

Half the room had plastic picnic-style tables and chairs, with laminated menus of 'prawn marie rose' and equally retro food. Though the changing room-cum-lounge-cum-café was labelled, in tiles, 'Frigidarium', the humid air was significantly warmer than that of the June day outside. But The Porchester wasn't going for 'retro,' 'vintage,' or any of those fashionable ideas that old is better – it had not changed, it seems, since the 1920s. The spa is a Grade II listed building, requiring that many of the original features be retained. It's a shame they're falling apart.

I began to descend the staircase, my hand running along its curving handrails, towards the depths of the spa. Halfway down was a landing with an icy plunge pool, which had steps going into it, a deep half-crescent of water to dash through, and steps leading out. Above the plunge pool stood a fabulous statue of a nude, green lady. I wondered if my friend Patricia, who had modelled for the statue of Princess Diana which used to be displayed in Harrods, had modelled for this Deco vixen, too. The statue stood in an elfin, dancing pose, firm-calved right leg on tiptoe, left leg swinging up, bent at the knee, right hand holding a torch at which she peered as if scrying (though if she was trying to tell the future of the spa, there was too much dust to know what she saw), the other arm swinging back, fingers splayed. Either she was the cousin of Puck, or was trying to bowl an invisible ball. Large mirrors surrounded the plunge pool so bathers could clearly see their own pained expressions as they flailed through the frigid water.

I descended further into the spa to find myself in increasingly steamy rooms. I was glad I brought my flip-flops, because other than towels, one isn't furnished with anything. And here, I realised, was why there were so few changing cubicles, and why we were told to wrap with a towel for the walk down the stairs. Because of course, many of the women were naked. The liveliness, the fleshiness of it all, was indeed naked – not nude. I began to wonder whether these words were about analogy: if 'naked' was to 'nude' as 'uncomfortable' was to 'comfortable'. And if so, who decides?

I walked through the rooms, trying to map my bearings. My spectacles quickly fogged up, so I alternated peeking into the different spaces and dipping into steam-filled rooms in which I could hardly see a thing. Down a corridor, I came across a pack of topless, fleshy older women, speaking Turkish. This was clearly their space. I'd hung my two towels on a rail in the first room, where there were also sinks and showers and, as I wandered back down the hall, a hirsute woman with pendulous breasts passed by, wrapping a towel around herself. One of my towels was gone.

Carefully, I made my way to a steam room with one or two other women in it, and settled onto a bench. I found myself trying to identify the scent of the air. Thermae Bath Spa, in Bath, has three 'aromatherapy pods' with different scents and temperatures, and I'd loved the eucalyptus, lavender, and frankincense diffused in the air. This didn't seem to have an intentional scent. However, the back-of the palate feeling was reminiscent of when I'd had a pet hamster as a child, and week-old clumps of urine-soaked wood-shavings were beginning to fester in the bottom of her cage. The old wooden benches had a touch of rot about them. The more closely I began to look at the spa, the more sorry I was for the state of the building, and the more sceptical I was about how much of the atmosphere I wanted to soak in.

Some of the original tiles were missing from spots on the wall, leaving bare plaster. Heavy tubes criss-crossed over-

head with flaking, asbestos-white paintwork, across which bloomed prints of mould. As I sat in a green plastic picnic chair in a corner of this subterranean place, I watched the flicker of people's footsteps on the pavement overhead through squares of frosted glass. I saw a movement on the chair across from me and watched as a small black beetle made a tour of the seat. Was it ... no, it wasn't ... maybe ... I wasn't sure I wanted to look. Then I saw a second. A third. Cockroaches: glossy, black, and completely unconcerned with my presence.

Many people would have been reasonable enough at that point to leave in a hurry, but I had a massage and a facial booked and was still willing to give them a try. I took refuge in the sauna. In the past, I'd usually found the hot wood rooms uncomfortable; I'd feel as if the fine hairs in my nostrils were being singed off with every intake of breath. This time, it felt clean. I began to wonder what that indicated about my own New England constitution. This desert seemed healthy and the dripping, fungal steam rooms did not. My interpretation was also humoral. The system of humours, devised by Hippocrates, aimed to balance the four bodily humours – black bile, yellow bile, phlegm, and blood. Each humour related to temperatures and to elements: thus blood was hot and wet, and of the air; yellow bile, hot and dry, and of fire; black bile, cold and dry, and of earth; phlegm, wet and cold, and of water. Though medicine has since relegated this system to the history books, it persists in ideas like 'detox,' in many holistic or 'alternative' therapies (think of the Chakras, for example), and even in the idea that one goes to a sauna to 'purge' something from one's system. Perhaps my dry, hot temperament preferred the wet-rooms; or perhaps I was cold and wet, and needed to be balanced by the hot, dry environment of the sauna?

Perhaps I didn't want to catch Athlete's Foot.

And what of the short, plump women who sat nakedly lathering themselves with soap, hosing themselves down

– quite literally; in one room there was a long, coiled yellow garden hose, and a woman sat in a green plastic chair, spraying herself with wet sloshes. I watched from across the steam-filled room until three other topless women came in, chattering away, and I slunk off.

I was, to my shame, reminded of having recently observed a pig at a farm. In old medical understanding, before genetics and the knowledge that apes were the nearest relatives to man, pigs were considered closest to humans, anatomically. A friend and I were enjoying a day out at Mudchute Farm, one of London's city farms, and stood at what looked like the empty pen of what a sign told us was a Gloucestershire Old Spot. 'Here, pig, pig!' we called, wondering if any creature was home.

There was a grunt and a crash, and an enormous beast appeared at the entrance to the sty, filling the doorway. It trod out and began rubbing against the robust fencing, only inches away from us. The description of the Devil as cloven-hooved was an accurate one. The creature was completely overwhelming: more than six feet long, it could have weighed 700 pounds. It had an exquisitely thick, long, cylindrical snout, wet and glistening with snot, streaked with dirt, eagerly pointing up towards us, dextrous and inquisitive. I'd never been so near to a pig. The snout was more elephantine than I'd have thought, like a very *truncated* trunk. The ears were magnificent – long, wide, and flat, they grew down and over the pig's eyes like the bad visors embarrassing relatives used to wear at summer picnics. The beast was covered in coarse, thick, distinctly individual hairs, like wire spikes. Pink skin shone nakedly beneath the hairs.

The pig snorted, snuffled, and seemed to scout us out, wrenching its heavy head back. I crouched to try to look it in the eye, but it seemed to keep them completely closed. It sniffed us. Maybe it was blind. The snout seemed lively enough. The pig seemed to enjoy a pat on the back. I touched it, hesitantly and not without disgust.

The beast frightened me – not only its size and evident power, but also the fact that everything about it seemed akin to the basest qualities of the human. It was dirty, fleshy, and as it bowed its head to munch a clot of turf, it made thick, wet smacking sounds as it chewed. It brought up all of the instruction I'd had as a child, not to smack one's food, not to chew with one's mouth open, not to fart – god, *never* to fart, we're Quakers – in front of anyone else, but *especially* not in public. This was, of course, a pig, but an irrational part of me felt it had very bad manners.

In the spa, as I tried not to stare at the half dozen stout women sloshing and washing, scrubbing themselves, exfoliating dead skin, soaping their heavy breasts, and gossiping in foreign tongues, I felt equally uncertain and wary, equally tense and prudish, equally judgemental and guilty.

Sitting alone in the dry sauna, I made myself take off my bikini top and stretch out on the hot wooden bench. *This* was being naked. *This* was flesh. Not the carefully shaved, perfumed, un-tanned and precisely lit body. It was *us*, humans, mucking about in this amphibian element. Strange that I felt so unclean in a hammam, which is all about cleansing. Weren't we all – like the pig – just so much bacon? Was I experiencing a fear of the other, a fear of aging, or a fear of catching some slow-growing fungal infection? I usually loved water, swimming, and an excuse to strip and dive into pond, lake, pool or ocean. This closed, wet space probably used to be magnificent. To me, it felt like a West London petri dish.

I watched the beads of water from the steam rooms slowly evaporate in the dry air, and a fine layer of sweat begin to develop all over my skin, down my legs and arms, and across my chest. I breathed in and out, shallowly, through my mouth, listening to the dry creak of a metal heater click on and off. Fifteen minutes is the recommended time to stay in a sauna before taking a break; I could last about five minutes before beginning to feel claustrophobic. I sat up, tied on

my bikini, slid on my flip-flops, and pulled the door handle, experiencing a second of panic before I realised the door opened outward. I stepped under a shower and pressed the button, gasping under the cold water.

Before going in for my massage, I made sure to wash off and cool down. The treatments were just as good as any I've had at a range of spas, from Bulgaria to Rhode Island, and the lady who carried them out was a friendly but no-nonsense woman in her forties who had worked there for 20 years. She said she only worked on the women's days, and that the atmosphere was very different on mixed days. As the masseuse dug her strong fingers into the knots at my shoulders, I closed my eyes and thought of Budapest.

One room, the empty 'wet treatment room,' which I peeked into, reminded me exactly of a post-mortem dissection room I'd seen in Berlin. Both were white and tiled, with high white marble tables, raised from fixed metal legs in the floor. Both had drains in the floor. At the spa, the name outside the door read 'slab room'. It made me shudder.

There were three rooms full of lounge chairs, and I imagined on busy days they'd be full of conversation. Maybe in the past it was the kind of space where businessmen made deals they didn't want on record. The rooms grew increasingly warm as one went further into the bowels of the building, and tiled words, one room to the next, read 'Tepidarium,' 'Caldarium,' and 'Laconicum'.

'Tepidarium' reminded me of a painting we were introduced to as students spending a year in England when we visited, among other places, Port Sunlight and the Lady Lever Art Gallery. The strigil that the pale, lithe, nude girl contemplates in the painting *The Tepidarium* is deliberately suggestive – it may not only be used for sloughing the skin. One friend called Lawrence Alma-Tadema, who painted *The Tepidarium*, a painter of 'high-class porn for Victorian gentlemen'. When, as a student, I saw the picture, I found it enchanting – luxurious and deliciously naughty. This real Tep-

idarium was empty, and the women abluting themselves in the other room would not have been Alma-Tadema's choice of subject. With all the bare young flesh in his romanticised paintings, it's not surprising that Ruskin considered Alma-Tadema the worst painter of the century.

I chalk my spa visit up to experience, real experience of the *everydayness* of flesh. But I'm about to encounter the question of flesh in a rather different light.

A teacher I know well, but haven't seen for a while, has booked me for a class that will take place over several weeks. In the months leading up to this particular modelling job, I've chosen to try a new contraceptive pill, after being on the same one for many years. Overnight, my figure has become *much* more curvaceous. My boyfriend loves it – 'your curves are ... curvier,' he says. But I hate it. I feel perpetually bloated: stretched, like an over-filled water balloon. My breasts are spilling from my bras – I've never had cleavage before. I feel matronly. Think of Joan in *Mad Men*, I tell myself. But it doesn't work. I feel fat.

And then my vanity is brought hilariously to light: the worst is confirmed. On the second week of the class, I'm in my robe, and the teacher points to the pose he's thinking of.

Oh God! I think. *I'm a Rubens?*

Peter Paul Rubens was known for painting plump, fleshy, dimpled women. The 53-year-old widower married 16-year-old Hélène Fourment in 1630 and they had five children. Hélène clearly satisfied Rubens's personal, as well as artistic, aesthetic. She modeled for her husband as well as other artists. In his book on Rubens, Gilles Néret writes that the poet Jan Caspar Gevaerts called Hélène more beautiful than Helen of Troy.[az]

I love food; I love eating. I love that many of my friends are also brilliant cooks. I can't allow myself to become too hungry, or my mood plummets with my blood sugar. When I feel out of shape or plump, I go for a jog, or a swim, or a

yoga class. It took me two years, at the end of my twenties, to accept that I had changed from a UK size 10 to a UK size 12. I have no patience for a starved look in fashion models. Every woman deserves to be proud of her natural shape, whether curvaceous or slender.

It was a side effect of the contraceptive I was taking that made me feel bloated and uncomfortable. I switched again and felt better, practically overnight. My shape and size probably did not change that much, but my perception of myself changed. I felt more myself; more comfortable; like I fit into my clothes. I felt I could breathe easily again. Comfort in one's skin and one's clothes enables one to feel beautiful.

Some see Rubens' women as fat and ugly. I can't help but look at the paintings and see lumpiness. It's not their curves, it's the bumpiness, that I object to. Smoothness is the key to beauty. I sometimes wear especially tight 'control top' tights and nylons not because I feel large, but for the smooth silhouette they create. But I also love that Rubens clearly loved flesh: he loved Hélène, who was so famous that poets celebrated her beauty. She looks healthy, plump, and proud. She looks like a very real, lively, woman. Considering she had five children over the course of the time Rubens painted her, she was probably pregnant most of the time, which may account for her full, unruly breasts – consider the painting *The Pelt*. I don't doubt that Rubens would have loved the chance to paint the women in the spa. But my own aesthetic, my vanity, makes me want to be a Venus by Velázquez or Cabanel, not a Venus by Rubens.

Chapter Eighteen

BELLADONNA, n. In Italian a beautiful lady; in English a deadly poison. A striking example of the essential identity of the two tongues. [ba]

It is the first day of our last week of class. The buzzer rings, and I stand to walk around the studio and stretch. Bill has been giving a demonstration across the room, but raucous, prolonged Sunday church bells drown out his voice. He's repeating the demonstration for Sarah, with a glass plate in front of him. He takes out a black plastic film canister, removes the lid and, with a small metal blade, lifts out a dose of white powder.

This is pure lead.

He tips it onto the glass plate and drops a little bit of oil – almond oil, baked with lead – onto the pile. He begins to mix.

He must get this question every time.

'Have you tested yourself for lead content?'

'Yes,' he says dryly. 'I haven't got any. I don't spread it on my toast for breakfast.'

He launches into an explanation about taking care, washing hands, being clean, tidy, safe.

Discussion about lead has come up in the class before, but only one of the students, a chemist, seemed to know much about it. She points out that people tend to know lead is dangerous, but don't know that cadmium, used in bright reds and yellows, is dangerous too. Cadmium poisoning can lead to respiratory problems and fatal renal failure. Chills,

fever, and aches associated with breathing cadmium fumes are known, poetically, as 'the cadmium blues,' but there's nothing poetic about hypophosphatemia and coma.

When I look up 'lead poisoning' online, it seems lead can be held responsible for every conceivable physical ailment. Lead can apparently damage all body systems, from cardiovascular to nervous. There is no known level of lead, however small, which is not harmful. Symptoms of lead poisoning include cramps, memory loss, pain, tingling, fatigue, headache, seizure, personality changes, constipation, diarrhoea, depression, anaemia, and on and on.

Lead is dangerous and it is everywhere. As Bill points out, being careful is the best way to handle it, if one must handle it at all. He advises Sarah to use titanium white paint, which doesn't contain lead. But for the demonstration, he shows her how to mix a small portion of lead white, and explains why it is often called 'flake' white. Lead, or flake, white is an opaque, pure white, which is very important in oil painting.

Bill tells us how a friend of his produces lead white using the Old Dutch method, or 'Stack Process,' thought to have been used by the Romans. Strips of lead are cut and coiled, and buried over vinegar and under manure in a hut, in ceramic jars. Acetic acid from the vinegar and the moist manure convert the lead into lead acetate; the carbon dioxide from the manure decomposes the acetate into lead carbonate. This flakes from the strips in large white chunks: hence 'flake' white. The white is ground into powder, which can be mixed with oil for paint[bb].

A particular noise in an oil painting class, quietly disturbing, is the sound of an artist scraping a painting. Oil paint is thick and opaque, sitting on top of a canvas: one can use a razor blade to carefully scrape away ridges and mistakes, from tiny strokes of paint, to the whole picture. The sound of scraping always sets my teeth on edge. If someone has used flake white or cadmium, we all must be wary of breathing dust and paint chips. I'm fairly certain most people in

my classes don't pay attention to this; perhaps they don't know of the risk. One of my London teachers is particularly anxious about a new student who has a tendency to chew absent-mindedly on the end of her brushes and gives her a stern warning. But another London teacher always has streaks of paint smudges across his own face. Once, it resulted, entirely by accident, in a rather dashing moustache.

As I become increasingly interested in watercolour painting, I realise that the things I know about oil painting are almost the opposite. One must build up an oil painting; one must build down a watercolour. With oils, I've watched as the wash is applied, a background colour covering the whole canvas, providing a base on which to build. Darks can be layered over darks, lights over darks, darks over lights. Highlights are put in, with great delicacy, at the very end. Bill only gets out the film container of lead powder at the very last stage of his work. With watercolour, one must plan the highlights from the beginning: usually, the paper itself provides any white in the picture. A dark colour cannot be undone, and a lighter colour will not work on top of a dark. There is no possibility of scraping off a watercolour: the best one might do is absorb the colour back into the brush before the pigment is absorbed into the paper, but all of this happens in seconds.

Oil painting is climbing a mountain; watercolour is finding all the caverns beneath. A painter must think backwards through a watercolour, must plan carefully. Most brushstrokes are a commitment that, in oil, could be scraped away. I find watercolour freer, looser, more impetuous, and maybe that's why I like it so much. I like the mess of charcoal and the unpredictability of watercolour. I've watched people slave at oil and it still doesn't look right. Later, thanks to Cassie, I'll discover oil pastels, and find they offer everything I like in a medium: they are textural, messy, and portable; you can build up the colours, light over dark, as with

oil paint. Oil pastels offer a rich array of colours, with vivid depth. They aren't as delicate as watercolour, though they can be, with a skilled hand, and they smell and feel wonderful. When I begin to dabble with watercolours and pastels, I love that I needn't worry about how well I'm doing. I have no aspirations to be a painter. I'm able to make attempts at watercolour and pastel, to try to employ the techniques I've learned in art classes, and to simply have fun.

Chapter Nineteen

The Beauty comes – had I but tongues of flame!
Of old hath much been sung to Beauty's fame;
Who sees her is beside himself with rapture;
Who owned her, all too high a bliss did capture. [bc]

'THAT LITTLE NOTCH on the lip,' Bill says, 'I can't remember what it's called...'

'It's called the philtrum,' I say from across the room.

I may not be able to see it, but I know what he's talking about. For the past two years, I've been studying anatomy: 18th century anatomical wax models, to be precise. In 1775, the Florentine Museum of Physics and Natural History opened to the public. Their most astonishing display was, and still is, a collection of wax models of the human body, originally intended as teaching tools for medical students. An insufficient supply of corpses for dissection, and their unbearable rot in hot months, led to the creation of painstakingly accurate models, some of which can be taken to pieces – virtually dissected. The most famous of these is the Florentine Venus, a life-sized female 'doll' that comes apart in layers, to eventually reveal a foetus in the womb.

I learned of this collection at Museo La Specola (nicknamed for housing an astronomical observatory in its tower) and began to research and write a verse drama on the subject. In an uncanny circularity of events, when the Atelier first contacted me about modelling, long before we knew it would be too cold for a nude pose, they sent a photo of Cabanel's *The Birth of Venus* (1863). 'I would love to do this kind of

project with you,' the coordinator wrote.

From writing about Venus, to posing as her: looking at Cabanel's gloriously pale *Venus*, I remember thinking about the impossibility of the pose. How did they do it? Her right arm is raised in a way that must have been propped up, or even suspended with a – hopefully soft – cord. I doubt her hair was really that long. And of course, Cabanel can't possibly show any pubic hair, underarm hair, or any other hint of maturity on this otherwise voluptuous woman, whose round breasts and childbearing hips indicate a developed, pubescent body.

In London, I visit The Courtauld Gallery expressly because I want to see Amedeo Modigliani's *Female Nude* (c.1916). The caption states: 'When a group of Modigliani's nudes were first shown at the Berthe Weill Gallery in Paris, police closed the exhibition, citing the depiction of pubic hair in some of the paintings as obscene.' It was this anecdote that sent me to the gallery. I stood, considering her ruddy, pink cheeks – flushed, perhaps – her pert breasts, her pear-heavy hips and thighs. The style of the face doesn't seem to match the style of the body. Her skin tones make me think of the warmer and cooler parts of my body as I pose. She has a strangely long torso, a convincing navel.

For all of her elongated voluptuousness, she'd seem strange *without* pubic hair – yet, we accept Cabanel's equally voluptuous, 'smooth' Venus. Why? Because it is working in a particular style, in a particular time? Or because she is a fantasy, 'Venus,' a goddess figure, whereas Modigliani's is, in fact, a 'female nude'?

Whatever I represent as a model, one philosophical point could be that my body is deficient. Why? Without either spectacles or contacts, I can't see clearly beyond about ten inches from my face – though of course, this makes no difference to the painters.

'We tend to group impairments into the categories of 'disa-

bling' (bad) or just 'limiting' (good). For example, wearing a hearing aid is seen as much more disabling than wearing spectacles, although both serve to amplify a deficient sense.'[bd]

Removing my spectacles is an important part of my transformation from person to model, just as putting on my robe, and then my specs, signals the transformation back. Without my specs, I'm ensconced in a soft haze; the room, the easels, the artists, all become blurred. I cannot distinguish faces, and I cannot see the eyes that are watching me. The few times I've worn contact lenses to model, I've been acutely aware of how much more I can see. It feels odd, veering towards the uncomfortable. Everything around me is more exposed to my sight, and therefore I feel more exposed, as if I can be seen more clearly in being able to see more clearly. The room, myself: we're both thrown into sharp relief. I don't like it. Added to the psychological discomfort is a physical one: the contact lenses feel dry and itchy; I blink hundreds of times more than I normally would, and I'm unable to relax my gaze.

For some portrait classes, the teacher wants me to leave the spectacles on. Some argue they help map my face, making it easier for intermediate or beginner students to mark my features in the right place. Some find the glasses distracting and off-putting; they dominate, adding hard lines to the soft landscape of my straight nose and indeterminate cheeks.

Technical challenges aside, I wonder if the painters also feel that my muted gaze abstracts me from them. They don't know how poor my vision is unless I mention it, but taking off the robe, then specs, is a motion, almost ritualistic, announcing, 'I'm modelling now'. Without my spectacles I can't knowingly make eye contact. To make eye contact is to connect, to challenge: I never do this on purpose. Does this remove, signalled by my removal of spectacles, make it easier to consider me as an object?

'For beauty here [in fashion models] is wholly in abstraction, in emptiness, in ecstatic absence and transparency. This

disembodiment is ultimately encapsulated in the *gaze*. These fascinating/fascinated, sunken eyes, this objectless gaze … are … Medusa eyes, eyes themselves turned to stone, pure signs.'[be]

Are my abstracted eyes 'Medusa eyes'? Vulnerable without my specs, retreating behind the fortress of my disengaged gaze, do I turn, in effect, to stone?

The bubble created by removing first my robe, and then my spectacles, is in my mind and my reality. My skin feels a protective layer of heat once I arrange the small, essential fan-heaters in a comfortable way. Reaching equilibrium, with no part of me too hot or too cold, is ideal. Once it's right, I'm cocooned in warmth. This is itself a challenge: it's easy to have a heater too close, causing florets of pink to bloom on my skin, making beads of sweat run from my underarms, tickling my bare side, whilst other parts of me – my bum or feet – turn to ice. I wonder if people notice the sweat. I hate feeling it – it makes me feel unclean: human after all.

In the 18th century, orreries were a popular way of depicting the cosmos as it was then understood. Before Copernicus's ideas were taken on board, the Earth was placed at the centre. People believed that the stars were suspended in a crystalline sphere, in an eggshell-like layer outside of the layer that held the planets, the Earth, the moon, and the sun. My heat-bubble creates an invisible sphere around me and, looking out, my poor vision creates another. Painters radiate around me: I am the focal point, the centre of this small, temporary universe. But it's my matter that matters, not my personality, not what I consider to be 'me'.

Over my years of modelling, learning that my body and looks are appreciated in a way that might be considered objectifying helps me to embrace myself as a whole being, rather than a disembodied cloud of thoughts. Rather than *unmake* me, becoming a subject and an object, being looked at and sketched out, has helped to merge my mind and my

body. By being taken apart into pigment and light, colour and shape, I feel more coherently assembled.

My significance at the centre of the orrery is wordlessly rejected in one class, where one student prefers to paint landscapes. Everyone else sets up at an angle to me that they find interesting. She turns her back, looking out the window to paint the scene over Albert Bridge. I am not needed. This is no affront; it is a preference. I am one thing to paint: she wants another.

Modelling is a mutual exchange; it cannot be one-sided. A body is only needed when an artist wants to paint a body. Even an artist painting a self-portrait is both actor and audience. I could sit nude in the centre of an empty room for my own benefit, but I don't. I'm comfortable being naked, but have no inclination towards naturism, and usually wear three layers of clothes at home rather than none, because I'm often so physically cold. (I'm typing this wearing a wool jumper, wool skirt, wrapped in a wool blanket, and my hands and feet are still freezing. Ah, London.)

Just as it would be unreasonable for me to feel that the lady who prefers landscapes is snubbing me, it would be unreasonable to feel insecure when, in a portrait class, more of the class choose to paint the grizzled older gentleman with weathered skin, friendly crinkly eyes, and a beard, than to paint me.

'You're too perfect,' a woman says.

I sit nude, leaning slightly back in a chair, for a figure class. The enormous back-up generator, brought in because the Victorian heating system in the building has given up the ghost, kicks in. It sounds like a rocket is about to lift off.

I have no graceful response to her comment. What can I say? Thank you? I'm sorry? Give it ten years?

The heater rumbles.

'The thing is, people won't believe the painting,' she continues, the tone of her voice friendly, straightforward.

'They'll think I'm lying, that I'm making it up.'

This has come up a number of times: old people, fat people, weathered people, are more interesting and, I'm told, easier, to paint. Imperfection is more believable. Comparing Cabanel's *Venus* to the flattering nude photo of me snapped by beautiful Nicola, there is a close resemblance in body shape and skin, in tone and texture. Not in the tiny flying putti or Pre-Raphaelite hair, but yes, at this point in my life, I could say my body is classical. Some artists, like Bill, love it, whilst some find it too blank. All I can do is offer myself as I am, and be grateful for how much I'm learning: about painting, about light, about the way people see. I will accrue scars with time, no doubt.

My interest in Cabanel's *Venus* grows as I read more about her. I'm intrigued that one artist thought my body type was near enough to hers to want to contemplate replicating the piece – and I'm relieved we didn't go through with it. Not only does her pose appear extremely uncomfortable, but she exists in an apparently transitory state: 'Her eyes ... seem to be closed but ... at close look reveal she is awake ... A nude who could be asleep or awake is specially formidable to a male viewer.'[bf]

Despite struggling to keep my eyes open after lunch, only once did I fall asleep whilst posing. It was a nude pose. The teacher laid out a mattress strewn with pillows and draped with a tan cloth, creating a curving, cushioned bed on the floor. I stretched onto it; my hips twisted to the side, my chest twisted upwards, one arm lay across my stomach, one above my head, in a faux-sleeping pose.

A twitch jarred me awake. Even if it was only for a moment, I felt more vulnerable for having drifted off than I ever felt lying there with my eyes open.

Marina Warner writes of a liminal state between waking and sleep, frequently depicted in the wax Venus models which appear to be both alive and dead. They are anatomised, their

viscera are exposed, but their cheeks are a healthy pink; their guts spill out, while their lips burn a sensual red. Referring specifically to the famous *Sleeping Beauty* waxwork, which Warner thinks may have originally been a wax Venus, she writes: 'Such a sculpture conveys a seductive vision of erotic, feminine catalepsy ... Images of sleep, dream, and trance communicate this [blessed] state, which lies in the zone neither of life nor of death, but somewhere else.'[bg]

'The entranced body,' Warner writes, 'has prevailed against the laws of death. Yet it also presents an enigmatic picture of sleep, when the self has also let go of conscious control ... The absent state of the *transi* might figure a condition of receptivity, like trance.[bh]'

Cabanel's *Venus*, in a trancelike sleep-state, is potentially receptive, especially formidable – possibly inviting a sexual encounter, or at least inviting the gaze. She is playing at being asleep, or allowing herself to fall asleep, and is therefore aware she is being watched. Or, she is uninhibited enough to be watched whilst sleeping, a passivity in appearance that is far from passive.

'Duty-bound.' A dominant-submissive power play is part of modelling. I choose not to complain whilst sitting, even if I'm uncomfortable. I allow myself to be given up to it. This is entirely my choice – not all models are so quiet and forgiving, not all models allow the time to pass however the teacher wants it to pass, however poor his timekeeping. As I've learned from Bill, I *should* bring my own timer. I don't. I like to please the class by being a 'good model', and this has inherently come to mean keeping still, and keeping quiet. No one taught me this, and no one told me, but the praise I receive for being 'a good model' reinforces my natural actions. I don't find a sexual gratification in this, but I find mental accomplishment in waiting ... waiting ... waiting for the class to end, in keeping still, in bearing the discomfort that may arise. This is small stuff, though: when it seemed I might be freezing for the month at the Atelier, I made sure

to speak up on the first day. I wasn't willing to bear that burden. It is merely a flirtation with submissiveness, much like Cabanel's *Venus* is flirting with sleep. Flirting with sleep is one thing, but when I *did* fall asleep, I didn't like feeling the lack of control.

Joseph Crawford writes of the mid-19th century fascination with 'the bound female body as a self-enclosed work of art in its own right, complete in itself. We do not, it seems, need to see the people who have bound her, or the people who are coming to save her. All that this aesthetic requires are the girl, and the chains.'[bi'] The various *Andromeda*s Crawford discusses (painted by Titian, Vasari, Doré, Poynter,) are visibly manacled. Cabanel's *Venus* and, whilst I sit, I, are shackled by our minds, our gazes, and our contexts. Mind-forg'd manacles are stronger than any others.

Crawford describes the 'complete detachment' of certain subjects, who are 'permanent objects of aesthetic and erotic contemplation for whomever might happen to pass by.'[bj] These women – particularly Poynter's *Andromeda* – do not struggle, but rather have what Crawford calls a 'settled stillness'. They too are *transi*, and thus both potentially vulnerable and inviting. My detached gaze, the feeling of inversion caused by my poor eyesight, may also contribute to the 'settled stillness' I willingly project when posing. I rely on those unwritten rules, the unspoken boundaries of etiquette and role. I may be completely awake, but my focus is blurred, hazy, in-between: vulnerable.

Chapter Twenty

*We cannot know his legendary head
with eyes like ripening fruit. And yet his torso
is still suffused with brilliance from inside,
like a lamp, in which his gaze, now turned to low,*

gleams in all its power. [bk]

It's 11:30 AM.
 'What are you thinking about?'
 'Lunch.'
 A chuckle.
 'Ah. I thought it would be something more ... philosophical.'
 'She's writing a novel in her head.'
 'That too,' I say. 'I'll have a better answer next time.'

What is the woman in the painting thinking about? She's thinking of how her left toes are feeling chilly, how her bare shoulders are cold, how that loose hair that worked its way into the top of her robe is tickling her back to the point of distraction. Yet she does not move. She needs to go to the loo, she wants a hot drink, when is she going to wash the laundry that's piling up at home, and is the spinach still fresh enough to cook tonight, or will she have to throw it out? The ends of her hair need trimming, when will she write to her mother, will it rain the whole month long? She's trying not to think of the man she loves, how she misses him, how his hands turn her white neck into something

ecstatic, or whether, if she drinks a cup of hot chocolate every afternoon, she'll get fat.

This is a far cry from the romance I imagined when I first considered being an artists' model. It is the reality.

The first 'proper' art show I remember visiting was an exhibition of John Singer Sargent's work in Washington, D.C. when I was, I think, 13 years old. The scale of the paintings impressed me most – I hadn't a clue about the technique or skill. It was the grandeur of the pieces, the beautiful women in their elegant gowns, the *frisson* of sexual appeal, which captivated me. The portrait of a dashing man in a red dressing gown who, in my mind, has become Sargent himself, is the first portrait he painted of a male subject: *Dr Pozzi at Home*. I recall being entranced by the richness of the red robes, the suggestiveness of the pose, that this founder of French gynaecology – a veritable expert with women's parts – was looking as if he'd 'slipped into something a little more comfortable'. It was all terribly Parisian and sexy to an awkward young romantic who had never been kissed.

Meanwhile, I still wore orthodontic headgear to bed which made me look like a telegraph wire, and on that same trip to D.C., I accidentally pulled off the door handle of the bathroom where I'd just showered, trapping myself inside for the better part of an hour while my aunt wondered what teenage vanity led me to take so long in the bath. I don't think it occurred to me to wish I was one of the women in Sargent's paintings, to imagine that I could look beautiful, elegant, and graceful – all things I decidedly was not – or to be immortalised in a way that would see generations looking upon the image with admiration.

It is nearing the end of my month in Bruges, and I receive a surprising email. It's from Daniele, the Italian painter with whom I swept into the British Museum.

'I am pleased to send you a picture of the first finished

painting featuring you ... of course it's not a portrait so I don't know if you recognise yourself, but the painting was a success. I am sending you also a preview of two decorative panels for my parents' country house in Sicily.'

I scroll through the pictures: a version of me, both more me and less – sweeter, softer, but yes, me – the first painting is of my head and torso, a bust. Then, snapshots of two full-length panels, in colours of spring: pastel blue and pastel yellow, hanging on either side of a gilded French settee.

'I still have to work on them,' Daniele's email concludes, 'but you might like the idea of hanging on the walls of a Sicilian villa!'

I'm delighted. I've never been to Sicily.

Months later, at the end of February in cold, grey London, I am back in the studio where the rocket-ship generator was standing in for the heater. The giant metal contraption has been removed, replaced with a dubious-looking pipe blowing warm air through a hole in the window. Three little space heaters warm up the cocoon around the model's stand. For the first half, I hold three fifteen-minute poses, and it goes wonderfully. I perch on a footstool, turning with each pose; for the second, I turn my back to the class and raise my arms, draping my hands over my head. A lady comments on how good I am at choosing poses and staying still. I haven't modelled for a few months and I'm relieved that I seem to be getting back into it easily.

After the break, the tutor shows me a picture of a painting, suggesting I try this for the long pose. It is *La Marietta* by Corot: the Roman odalisque. She is long and pale, with dark hair and a smooth, thick thigh turned towards the viewer. Her knees face away, showing a long expanse of rump, while her torso is twisted towards the viewer, her arms above her head, supporting each other, her neck turned.

For the first time, I cannot even get into the pose, let alone hold it. While in the painting the woman appears graceful, I

am crumpled and uncomfortable, and not in the right position. The same lady who complimented me earlier says that the angle of my neck is awkward: she is right; in fact, at least half of me looks and feels awkward. I arrange my legs and hips well enough, but immediately admit that I won't be able to hold up my left arm over my head as in the painting. I've made a mistake: the left arm is being supported by the girl's head; it's the right arm that becomes agonising, as it ends up crooked at an angle, supporting my head. Later, I will stare at the painting and wonder what I was doing wrong, wonder whether the poor girl suffered as much pain.

Even though we arrange breaks every twenty minutes, the muscle fatigue makes my head tilt back on my neck. My right arm goes numb, yet still manages to hurt incredibly. I feel like a bow, taut, ready to snap; the tension is such that I can't imagine anyone is painting well from me. It seems like it would be better to admit defeat and start again, comfortably, so everyone can work comfortably. No one says anything. I don't say anything.

It is the longest hour I've ever sat. I feel like a failure. Afterwards, I drag myself across the street and spend the money I've earned modelling on a back massage. Maybe I'm not able to do this anymore. Maybe I'll never model again.

'The head is heavy, the neck thin, and the very physics of this arrangement work to the artist's disadvantage, as people fidget and shift just to take the strain off their necks.[bl]'

'She was a mover,' a friend explains, showing me three large pencil sketches of nudes. He's been going to local classes in Oxfordshire, held at people's homes, informally, for anyone wanting to draw from life. The first sketch is of a large woman on her side, drooping belly and breasts pouring out onto the page. I ask if she was pregnant, but no, 'she was just fat,' he says. He agrees that it is much more interesting to draw a shapely person, that there is more to look at, more shadow and shading. He's done a wonderfully shaded

sketch of the same woman sitting upright, legs curled up. He's found her contours, and this time there is no question that this is a curvy model rather than a pregnant one. The third sketch is more classically beautiful; a thin woman, whose shape he's captured in a few lines – lovely but simple, without a lot going on. I can see that he's responded with much greater interest to the larger model, and therefore she is more three-dimensional on the page. She was a good model – it shows in his good drawings.

I thank him for showing me the sketches.

'I just wanted to know if you thought they were any good,' he says. I do think they're good; I'm also surprised that he thinks being a model would give me authority about skill. I suppose I've seen many works in progress.

I ask my friend's partner, who has also sketched in life-drawing classes, about her practice as a masseuse.

'You're basically dealing with naked people,' I say. 'Is it ever weird?'

She considers. 'No, because I don't really think of them as naked,' she says. 'They become muscle and bone under my hands and it's about working that, not about whether or not they have clothes on.'

I like the materiality of this, the fleshiness of it, but also the abstraction. In being less personal, perhaps, the masseuse can become more intimate; can dig more deeply.

The first metaphor that came to my mind when I posed for the first time was, 'I am a vase.' I felt like a glass container, not so much to be filled up, but a form that wasn't complete, an outline for the artist to finish. Looking back, it is tempting to see the psychological implications of the metaphor, but at the time, 'I am a vase' didn't mean 'I am empty: fill me'. It was simply the nearest metaphor to an inanimate thing. I was seeing myself as an object.

Steinhart quotes model Rashmi Pierce: 'I'm there to have them draw. Not draw my contour, but my energy.[bm]'

Not me. They are drawing my contour: I offer my material self to the artists and I go somewhere else, in my head. Reading Steinhart's book, I conclude that I'd make a poor model in California, where it seems modelling has evolved into a combination of all-American competitive athleticism and West Coast 'exchange of energy'. There are inevitably different cultures of modelling, so it is no surprise that I've become one of the British, buttoned-up, don't complain, freeze-your-ass-off variety.

Chapter Twenty-One

The sound of trumpets died away and Orlando stood stark naked. No human being, since the world began, has ever looked more ravishing. His form combined in one the strength of a man's and a woman's grace. [bn]

ART HISTORIAN Johann Joachim Winckelmann 'asserted that the highest beauty should be free from all flavour, like perfectly pure water.'[bo] This makes me think of actress Tilda Swinton. In her book *Phantasmagoria*, Marina Warner considers the appeal of Swinton as a living (and clothed) art installation, *The Maybe*, at the Serpentine Gallery in 2005.

'They looked at the faces [of the portraits] intently, unblinking, with a concentration, a frankness and a questioning they could not bring to a living visage, because here it is not impolite to stare.'[bp] Here, Steinhart writes of visitors to an art gallery in a different time and place, but the effect of *The Maybe* was similar. There is a fascinating array of commentary about *The Maybe*. One artist from North London said, 'I found it interesting that every time she turned over, everybody moved to the other side of the case. They didn't want to watch the back of her; they wanted to see her face. I don't know what they were expecting to see.'[bq]

Swinton's performance provided a mixture of voyeurism and the artistic gaze, of vulnerability and power: some viewers were baffled, confused, angry, or scared, while others were emotional, finding the pose sensual, beautiful, otherworldly. Swinton inhabited a liminal space (object or subject?) embodying a liminal state (alive or dead?) with her

in-between physicality (man or woman?). It is this boundary-crossing that has historically caused celebration and frustration, approbation and disapproval.

When I first saw Swinton in a film, I was struck by how odd she looked. Her androgyny is unmistakeably powerful, but I wasn't convinced of her beauty until reading the quote from Winckelmann. She seems 'free from all flavour, like perfectly pure water'. This is why she is most convincing as an androgynous character, perfect for her role as Orlando in the 1992 film. I find Swinton far more convincing as a man than a woman. In the scene where she stands nude in front of a full-length mirror after her sleep-induced change of gender, her head doesn't seem to match her voluptuous feminine body. I find Swinton such a 'pure water' beauty that she isn't sexy: hers is a beauty of which Ruskin may have approved.

We seem to consider beauty as 'either/or': abstract and spiritual, or sensual and sexual. Whereas the Knidian Aphrodite is stepping into her bath, unconcernedly exposed, Clark explains, the Capitoline Aphrodite is coquettishly posed, half-covered: 'herself self-conscious, she is the product of self-conscious art.'[br] Aphrodite, in covering up, admits there is some reason to cover up.

Edouard Manet is a painter whose self-conscious subjects brought him much attention, and perhaps his most discussed painting was, and is, *Olympia*. A nude, reclining woman, always a popular subject of painting, was commonly titled 'Venus,' such as Titian's *Venus of Urbino* after which *Olympia* is staged. Kenneth Clark argues that Manet's *Olympia* caused a scandal because, 'to place on a naked body a head with so much individual character is to jeopardize the whole premise of the nude'. The model was not an abstract representation of a goddess, or even an abstract representation of a prostitute ('odalisques,' or women from a harem, were popular subjects,) but a recognisable woman,

Victorine Meurent. Meurent was a model, music tutor, and painter: 'By 1875, she had returned to Paris and was attending evening classes at the Académie Julian. Her self-portrait was shown at the Salon in 1876, and after that her work appeared there in 1879, 1885 and 1904. In 1903 she was elected a member of the Société des Artistes Français.'[bs]

Meurent is probably the model Manet depicted in the most diverse range of roles. In a 2013 exhibition at the Royal Academy of Arts, Meurent is described as the subject of a 'straight portrait,' (*Victorine Meurent*, c.1862,) as a bold nude (*Dejeuner sur L'herbe*, c.1863-8,) the controversial *Olympia* (c.1863,) and the beguiling young woman in *The Railway* (1873). In *Street Singer* (c.1862,) Meurent poses as woman on the fringes of society, provocatively eating ripe cherries as she holds a guitar. The latter painting, showing a hungry girl with dark shadows around her eyes, could be interpreted as tragically prescient: Meurent was often cited as having fallen into poverty and alcoholism, now a strongly contested point. Meurent did struggle with poverty. She wrote to Manet's widow in 1888, six years after the painter had died, when the model would have been 44:

'No doubt you know that I posed for a great many of his paintings, notably for *Olympia*, his masterpiece. M. Manet took a lot of interest in me and often said that if he sold his paintings he would reserve some reward for me ... Certainly I had decided never to bother you and remind you of that promise, but misfortune has befallen me: I can no longer model, I have to take care of my old mother all alone ... and on top of all this I had an accident and injured my right hand ... it is this desperate situation, Madame, which prompts me to remind you of M. Manet's kind promise.'[bt]

What interests me particularly about Victorine's appeal is how it is treated in books of art history now. The appeal for funds is often cited, but the next sentence of the book always moves on to something else. Did Mme Manet respond? Why don't any of the art historians acknowledge whether or not

there was a reply? Because, one is tempted to conclude, Victorine only matters in light of Manet, not for herself.

V.R. Main, author of a fictional take on Meurent's life,[bu] comes to a particular conclusion: 'Madame Manet, who had inherited most of her husband's paintings and was in the process of organising a sale, ignored the letter'.[bv] This interpretation, even word choice ('ignored,') creates a hero/villain scenario appropriate for fiction, but it is difficult to know what really happened and why. We do know that Meurent lived to be 83, which suggests that she was unlikely to have been Manet's lover, as the painter died due to complications from syphilis.

In the RA exhibition, Manet is championed as a painter 'well aware of the ease with which he could move his sitters from one category to another. When Nina de Callias's estranged husband objected to *Woman with Fans* (1873, Museé d'Orsay, Paris,) being exhibited as her portrait, Manet reassured him that: '[It is] a fantasy figure based on Madame de Villars [sic] and not a portrait'.'[bw]

This complex dynamic of familiarity and abstraction is why I am not usually posing for 'a portrait,' but simply as 'a woman,' and why Daniele was able to paint several full-length versions of me to display in Sicily – not of me, but 'a woman,' just as easily named 'Venus,' 'Spring,' or 'Olympia'.

The pushing and pulling of Manet's sitters from portrait to posed scene is why it is difficult to distinguish Meurent as a model, a 'woman posing as X,' and a person in her own right. One might say that when modelling, I'm allowed to be anyone but myself, whereas for Swinton, in *The Maybe*, the appeal of the installation might not have worked had she been anyone but herself. It is also the difference between Swinton's fame, and my anonymity.

Chapter Twenty-Two

*I wish men would get back their balance among the elements
And be a bit more firey, as incapable of telling lies
As fire is.* [bx]

THE *ICE AGE ART* exhibition at the British Museum in 2013 is full of 'Venus' figures. Most of the pieces are pocket-sized; small objects for nomadic peoples to carve when crouching, perhaps, beside a fire. I long to touch the objects. They were made to fit into the palm of the hand, and what understanding I might reach towards is incomplete without being able to hold them. But these are precious for their rarity, and incomprehensibly old. A 22,000-year-old figure from Barma Grande, Italy, with a triangle of three round figures: head-and-breasts, a rounded belly, wide hips, and deep 'V' between the legs, is juxtaposed with modern pieces by Henry Moore and Brassaï.

I marvel at the ancient objects: their smallness, their uncanny familiarity. These figures are humanoid, carved by our human ancestors. The interpretation of the exhibition, the *Modern Mind*, is frustrating. I do not want to be told what to think of these things. We cannot know precisely what they, the makers, thought of their carvings, but we can enjoy our own responses to them.

T.J. Clark writes, 'The frightful *Polichinelle* from Grimaldi opens her vulva imperturbably on all efforts to address her thus [using neuro-interpretation,] the eyes of the woman in ceramic from Dolní Věstonice look out and past any possible viewer with unfathomable disdain'.[by]

I like Clark's projection onto the ancient figures, that they may consider neurology with disdain. Fuck modernity, they seem to say. We're interested in more important things: the old things. Life and death.

'Beats me what the *son et lumière* was about,' writes Clark, of the practice of putting figurines into the fire deliberately, so they would explode. Of course we speculate, wanting to understand. With objects so old, we never will, and it's delicious. But I don't think that whatever would compel our modern, or present-day interest in the Venus would be vastly different from that of someone 22,000 years ago. Sex, procreation, health, protection, spirituality. The old things: life and death.

Perhaps this is why the modern pieces woven throughout *Ice Age Art* are also so appealing. I am most enchanted by the Brassaï pieces, found stones sculpted, polished, *pushed* in their 'natural' direction – shapes in which the artist saw, and named, the female form. In this case full of female figures are a number of objects in which I struggle to see any form, let alone a human, female nude: 'silhouettes' which seem accidental. Shapes that, to my eyes, look more like a whale's tail than a pair of legs. Pareidolia is the phenomenon of seeing faces in random shapes, and I wonder how certain we can be that these objects were intended.

Is this trend for big exhibitions on 'the making of the modern' a crying need to understand ourselves, selves from whom we feel alienated, because we are fiercely competing with and thus alienating one another? Are we trying, culturally, to define these ancient unknowns because we feel unknown to ourselves and cannot bear the uncertainty? Figures like the *Pregnant Woman* from Kostienki and the *Woman* from Dolní Věstonice were deliberately carved, even if we can't know, for certain, what for. They were almost certainly created within a small, close-knit community. Maybe they were carvings *by* a pregnant woman or, more obviously, *of* a pregnant woman. As Clark writes, 'Whatever cluster of

powers, dangers, potentialities, causes and effects may have been gathered up, for the image-maker and his audience, in a notion even roughly equivalent to the question-begging word 'pregnancy' is of course a matter of speculation. The archaeologists admit they haven't much clue.'

If we do take these figures to be pregnant women, might we be imagining the first model, the first naked muse?

The *Ice Age Art* sculptures also make me think of Barbara Hepworth's work. The most immediate, the most honest, moments of understanding I've experienced with an art object, have been through Hepworth sculptures. The first time, I wasn't yet familiar with her work. Her name was in my head because a friend had just returned from the Hepworth Wakefield and was telling me about it. Shortly after, I was in the Ashmolean and, walking from one room to the next, found my eye instantly drawn to a form. 'That's a Venus,' I thought. It was long and sensuously curved, made of polished, glossy blonde boxwood. I wanted to touch it: that curve of light across the object provoked the longing of the stroking hand. It seemed to me the absolute essence of a Venus. The sculpture suggested, rather than stated, *woman*, expressing the twist of the hips, the strut of a leg, without having hips or legs.

As Kenneth Clark writes, 'The swing of the hip, what the French call the *déhanchement*, is a motive of peculiar importance to the human mind, for by a single line, in an instant of perception, it unites and reveals the two sources of our understanding. It is almost a geometric curve; and yet, as subsequent history shows, it is a vivid symbol of desire'.[bz]

Powerfully present, the statue communicated all of this from across the room. Upon closer inspection, I discovered it was Hepworth's *Single Form (Antiphon)*, carved in 1953. She carved the boxwood with such love and skill that she revealed both a geometric curve and an almost liquid symbol of female form.

In Bruges, the paintings for which I'm sitting that I like best are half-complete. It seems I prefer works in progress. The yellow-orange tones of one in particular reminds me of Da Vinci's sketchbooks: it has an antique quality. Though I'm the model, it could be anyone. The painting is still in the stages of being 'drawn' in paint, showing glowing skin. The edges of my face blur, my right ear a mere suggestion. For similar reasons, I like certain impressionistic pieces, like Manet's painting of Mme Manet in a pink dress, her cat curled contentedly on her lap. These paintings are full of motion, evidence of the painter's process. This is why, much as I am awestruck by photograph-perfect, hyper-real pieces such as those Bill paints, I prefer the texture of unfinished paintings.

While I understand the criticism of writers like John Berger and Susan Sontag about the reproduction of images, I am of the disposition (the culture, and perhaps, the generation,) to snap photos casually and buy postcards of paintings I enjoy in order to help me remember them. A selection of postcards adorns a corkboard in my bedroom: a kind of 'working collage,' for writing this book.

At the moment, they include Whistler's portrait, c.1938, of Lady Caroline Paget. A boyfriend sent me the postcard, writing, 'An American femme fatale painted by a besotted Englishman. Ring any bells?' The note makes me smile, thought the expression on Paget's face is somewhat sad. A friend, who also models, sent me *Le Bain de Diane*, c.1873, by Corot. The pale nude poses, definitely self-aware, in dappled sunlight. Velásquez's *Lady with a Fan* (1599-1660), courtesy of Bill, looks out at me inscrutably.

There is also a photograph of *The Tetons and the Snake River, Grand Teton National Park, Wyoming, 1942*, by Ansel Adams. In the photograph, I see a grand version of Hogarth's sinuous curve, the line of beauty. There is a postcard of the 22,000 year old Barma Grande female statuette, and a photograph of the marvellous Florentine *Anatomical Venus*, star of

my verse drama. Finally, there is a postcard entitled *Floating People*, of four handmade glass figurines by Simone Bremner. I saw these at an art fair in London and loved them. They manage to conjure ancient mummies as well as the abstract sculptures of Moore and Hepworth in their shapes, whilst implying the busy chemistry of the body by the varied colours and squiggles embedded within the glass.

It is only my subjective taste that connects these seven postcards of seven images. And each painting, watercolour, charcoal sketch or photograph for which I pose is different, thanks to the subjective taste of the artist.

Perhaps this is why I am most responsive to works-in-progress: I too am a work-in-progress. The selection on the corkboard is constantly changing. At one point they were all paintings of boats by Alfred Wallis, which suited my mood at the time. The selection of postcards is my version of carving a figurine – a 'cutting out' (from hundreds or thousands of pictures one might see in a day,) of images that capture what I want to express. It is this evolution, this process of becoming, that interests me. The mistake is to think there is an end point, a *become*.

Chapter Twenty-Three

'Tis the year's midnight, and it is the day's,
Lucy's, who scarce seven hours herself unmasks. [ca]

SEVERAL YEARS AFTER I first work with Daniele, he gets in touch again. He is painting a frieze for a chapel in Sicily, and asks if I would be interested in modelling for it. It is a unique request in my modelling experience, and I enjoyed working for him the first time, so I agree. We meet at his flat just after Christmas, when heavy rains have caused flooding all over the country. I navigate puddles as I make my way across a park to a Victorian conversion. There, Daniele introduces me to his elegant partner Caron. I admire paintings in the living room, all recognisable as Daniele's work – a portrait of Caron in a red jacket; several paintings of a young man which make me think of Dorian Grey before he went bad, and two canvases of a woman, reminiscent of the photo shoot in the British Museum.

We sit, and, showing me photographs on his laptop, Daniele describes the commission. 'As you can see,' he says, 'the chapel is...' he hesitates, 'ugly. Like a car garage.' The architecture is modern, brutalist, a small space of concrete and steel. It reminds me of the Quaker Meeting House in Blackheath Village, a space in which I have both sat for Meeting and practised yoga. Though the Meeting House seems at first a hard, barren space, the high tower and natural light make the feeling on the inside entirely different – calm and peaceful. I wonder if Daniele's chapel in Sicily has the same effect, or if it is, in fact, just ugly.

'So it will really benefit from your artwork,' I say, encouraging him to continue.

The altar is set in front of the obtuse point of a 'V' where two walls of concrete bricks meet. Above the bricks, before the roof begins (it looks like corrugated steel, or the kind of folding metal that old garages sometimes have, that roll up in a racket of noise,) there are two strips of wall painted an institutional green. On the computer, Daniele has marked the space with dimensions, but I'm terrible at remembering numbers, so I don't take them in. Daniele mentions that he will need to rent a studio for this project. The frieze – the arms of the 'V' – will be two rectangular paintings, with the crucifix hanging between. 'Eventually there will be a larger crucifix,' he explains, 'but the church cannot afford it now, so there is a small one.'

He goes on to show me his sketches. I've been curious to know which figure from the Bible he wants me to be. As I look at the frieze, busy with – I count – *seven* people, my curiosity grows. I am not adequately versed to know who's who. On one side of the frieze, three women and a man compose a tableau, on the other, two women and another man.

Daniele points: 'I thought you could model as St Lucy,' he says.

'Sure,' I say.

'And St Agnes,' he continues, 'and Agatha…'

It's going to be a busy morning.

As Caron makes tea, Daniele flits about, making sure I'm comfortable, fussing with the camera, and testing the angle of the light. He is like a bowerbird: small, precise, energetic. Everything must be right. He apologises constantly. I try to say soothing things, to let him know it's ok and that I'm comfortable. One of the first things we establish is that all of the figures will be thoroughly clothed, draped in many layers, only, perhaps, revealing a wrist. The priest of the chapel wants the image to be modest. The figures in the

frieze, Daniele explains, are all fairly young, and some are local, Sicilian saints. As I pose throughout the morning, I learn more about them.

For that Old Masters, north-slanting light, we go to the bedroom. The flat is beautifully tidy, and I'm hesitant to sit on the bed and crumple its fine paisley throw. Despite the grey, rainy weather, a large window gives us magnificent light: it has long shutters and a high section at the top with separate shutters, so Daniele can close the bottom half and create what Bill set up in Bruges: high, slanting light in an otherwise dark room. The difference is that this Victorian window has a trim of blue stained glass, creating a cool, blue light mingled with the grey of the English weather outside. It is just the right tone.

Asking me to leave on my blue corduroys and black cashmere jumper, Daniele drapes me in a toga of taupe fabric, apologising for the plastic smell of the new cloth. I've taken my shoes off, afraid of dirtying the fine beige carpet that covers the entire flat, and the fabric falls far beyond my feet, covering my blue striped socks. That morning, I tied my hair, now longer than shoulder-length, into a French plait, and brushed on my usual, simple make-up. I take off my new, large blue spectacles – *not* Biblical – and we begin.

First, I'm to be St Lucy. I perch on the bed as Daniele dashes into the kitchen to grab a plate.

'This is for her eyes,' he says. 'Her eyes were –' he makes a clawing motion at his face, searching for the English word. My stomach flips.

Plucked out? I think. *Gouged?*

I hold the plate, draping my fingers as Daniele asks, and look towards the light.

Lucy's eyes were later restored – God granted her an even more beautiful set, Daniele tells me, when I ask if he would paint this figure without eyes. So: two pairs of eyes. I wonder if he will paint *my* eyes, sitting on the plate in my hand. The young Lucy was condemned to death for distributing

her wealth to the poor – she had decided to devote her life to God and works of charity, and by some error of miscommunication, she'd also been betrothed to a man who objected to her giving away her gold and jewels. Only later accounts of St Lucy describe the loss of her eyes – in some tales, they are cut out by the guards ordered to execute her; in other versions, she does it herself, to deter an admirer. Over time, the story has meant that St Lucy has become the patron saint of the blind and poor-sighted, and as I look up towards the window, my fuzzy vision feels all too appropriate.

The feast day celebrating *Santa Lucia* is the Winter Solstice, appropriately celebrating the Latin root of her name. Lux: light. The customs of the day originate in Sicily. A traditional dessert is wheat in hot chocolate: the soggy grains of wheat are meant to represent Lucy's eyes. That fact makes me blench; there is a lot of cannibalism in the Bible. Reading about St Lucy only adds to my bewilderment about Christian myths – it seemed that the more holy and protected she was, the more the authorities (who were pagan and busy persecuting Christians at the time,) tried to harm her, first sentencing her to prostitution, then attempting to burn her, in some accounts gouging out her eyes, and finally stabbing her to death. Somehow this has become a celebration, where people drink Lucy's 'eyes' in cocoa. I can't pretend to understand.

I find a redeeming poem by John Donne: 'A Nocturnal Upon St Lucy's Day'. Harshly beautiful, it highlights the darkest day of the year, and the elusive love, lust, and life which yet grows from it: 'Study me then, you who shall lovers be / At the next world, that is, at the next spring; / For I am every dead thing / In whom Love wrought new alchemy.' Though in religious festivals, Lucy represents the single luminous point in the winter solstice, Donne celebrates, perhaps more appropriately to Lucy's story, the very darkness of her memory. Herein lies dormant a seed of hope: 'He ruin'd me, and I am re-begot / Of absence, darkness, death: things which are not.'

Daniele is painting the frieze in Scordia, for the Church of

St Domenico Savio. That is also the name of one the saints he will paint. The boy was one of the youngest children ever to be sainted, when he died of an illness at only 14 in the midst of studying to become a priest. The other male in the frieze, St Lawrence, is at the heart of all quests for the Holy Grail, for it was he who stole the golden chalice, used at the Last Supper, and hid it somewhere in Spain. When he was ordered to hand over the wealth and treasures of the Church, he brought forward a number of blind, ill, and poor people, saying that these were the treasures. The prefect was so angry that he ordered Lawrence to be martyred by being slowly cooked alive on a gridiron.

Supposedly the saint said with enthusiasm, 'I'm well done. Turn me over.' This ridiculous interpretation arguably came from the misreading of a single letter, which changes the Latin from 'he suffered' to 'he was roasted', an interesting linguistic trick. Gridiron or no, St Lawrence is considered the patron saint of chefs and cooks.

I wonder if the young ginger-haired man in the paintings, Daniele's Dorian Grey, might be the model for the male saints. Caron's features would be beautiful, but for these very young saints, Daniele would need to change the features. Most of the martyrs I'm sitting for are only 16, and I'm sure Daniele is planning on making my features younger, too. When we break for tea and biscuits, we flick through the photos Daniele has taken so far. Caron compliments me on the mobility of my look. 'How different you are in each of these!' he says, as we all take sips of jasmine tea. As the partner of a painter, he understands the substitution of modelling – they tell me how, earlier, Daniele set Caron up to pose for all of the figures in his frieze sketches, one at a time, so he could try out angle, pose, and poise.

Next, I pose as Sicilian St Agatha. After instructing me to pretend to hold my plucked-out eyes on a plate as Lucy, Daniele explains that I need to lean forward, clutching a scarf of blue cloth to my chest.

'Her breasts were cut off,' he explains mildly.

Perhaps there is something lost in translation, from his gentle Italian to a soft English that sometimes hesitates for words. I simply don't know what to say, and so I hold the cloth and lean forward, wondering if my expression is meant to convey pain or rapture. Both, no doubt. I think of how Daniele, this sweet painter, comes from an Italian Catholic tradition. Perhaps he knows these tales from childhood, from church, or perhaps he had to research them for his sketches. He tells me he wanted to work with me again because, he says, 'you have a classical face'. I remind myself that these stories of mutilated saints are old, worn down over time. Depictions of martyrdom have blended with the classical ideal. Distance: how else to reconcile someone looking at you and saying, 'oh, you'd make a *great* martyr!'

One friend, with an appreciation for the history, art, and architecture of churches, teaches me some of the symbols in religious art. For example, Saint Catherine holds the wheel on which she was sentenced to be broken. When that failed, she was beheaded. I especially admire the various ways that a halo, or a Paraclete – the symbol of Christ, usually in the form of a white dove – can be depicted.

Once I'm done contorting myself as St Agatha, we move on to St Agnes. A beautiful 13-year-old who refused all suitors, including the Governor's son, Agatha had promised herself only to God. Because of the composition of the frieze, Daniele has me turn and point my right arm in one direction, and twist my head over my left shoulder. 'Agnes is usually shown holding a lamb, so I'll paint a lamb's head here,' he explains, showing me a sketch. Several things run through my mind: how fun but difficult it would be to pose with a lamb; the severed head of a lamb on a platter. 'A ... head...?' I ask. Daniele chuckles. 'A live lamb,' he clarifies. Unfortunately, he does not have a real lamb to paint and I must curl my arm around empty space.

To pose as the last and youngest saint, Daniele wraps my

hair in a turban of taupe and grey. She is a modern saint: her story is well known, the dates and details specific in their horror. Maria Goretti was born in 1890 and died in 1902, stabbed to death by the nineteen-year old son of the family on whose farm the impoverished Goretti family lived and worked. Alessandro Serenelli made repeated attempts to rape the 12-year-old Maria, and finally, as she cried out that the act was sinful and against God's wishes, he attacked her with a dagger, stabbing her 14 times. He later claimed that she died a virgin. As she died in hospital, she forgave Alessandro, and he went on to become a lay brother in a monastery, where he lived to be 87 years old. Assunta, Maria's mother, was the first mother ever to be present at the canonization ceremony of her child. Maria is the patron saint of chastity and virginity.

Though I am not here to pose as anything but a body for this frieze, to provide those classical features that Daniele is looking for, I am most moved by this story. I am certainly not young enough to 'be' Maria Goretti, but I also wonder whether I am worthy to stand in for her. The facts of her life – her grace, her endurance, the cruelty of her death – make me want to provide, for her memory, an honest respect. Her life is being turned into myth; there is even a film about her. But the facts of her death touch me most deeply.

I fear that the image to which the people of the church of St Domenico Savio will pray may be barren of religion. I am not free of vanity or ambition, lust or gluttony, jealousy or pride. Yet it is up to Daniele to paint the frieze, to take the photographs of me and paint them into something that transcends these human follies. The transformation of image, the power of the icon, the weight we put onto it, has the power to be deeply unsettling. Despite all of this, I hope to provide a body that will be transformed, providing peace, beauty and comfort to those at prayer.

My last figure for the frieze is to be a nun. St Therese of Lisieux died of tuberculosis at the age of 24, in 1897. Her wish,

to be devoted to her religion in a quiet and unobtrusive, or 'little' way, is what has, ironically, led to her fame: she is one of the most popular Catholic saints. She even objected to the 'improbable things' said of the lives of saints, writing, 'we must see their real, and not their imagined, lives'. I wonder how, in stories, we can be certain that anything is real.

Once Daniele has the pictures he wants for the frieze, he has another portrait request – one completely different. 'I want to enter the BP Portrait Award,' he says, 'and I decided this year to ask someone famous, but she said she'd think about it. I am not sure I will paint you, but would you mind...?'

'Being your back-up?' I say, laughing. 'Why not? I'd be happy to. May I ask who this famous person is?'

'Mary Beard.'

This makes me smile: Daniele is a Professor in the History of Ancient Philosophy in Italy. I'm glad that his idea of a famous person is a Cambridge academic. I agree to play understudy to Mary Beard, and we discuss how the portrait should look.

He takes close-ups of me both with and without spectacles; for variety, I suggest the spectacles might have a modern twist, which seems to be popular with the BP selection panel. I recall the stunning, large-scale painting of a young woman with pale skin and strawberry hair, with the only hint of its place in time the eerie wires of white iPod headphones twisting out of her ears. It was modern, uncanny, and very beautiful.

'How would you want to look for your portrait?' Daniele asks.

'Books,' I say without hesitation.

But we try to include a stack of large, hardcover art books and the poses Daniele suggests look, to his dismay, 'too Victorian'. His style is soft and classical: it is beautiful, but practically the opposite of, say, Lucian Freud.

Caron comes into the room to discuss ideas and it hap-

pens: a photographic accident. A striking image: me sitting on the edge of the bed, looking directly at the camera. The composition is made especially striking by the figure of Caron in the background, blurred and out of focus, standing in a military style, as if he was just told to be 'at ease', his hands folded behind his back. The photograph is full of potential energy, the black of my jumper and Caron's trousers saturated, my skin pale and glowing, the blue-purple of my spectacles adding an interesting frame to my face. It could be a great exercise in psychoanalysis: there's a foreboding tone to the figure in the background, and my Mona Lisa stare could mean anything.

Chapter Twenty-Four

Now through night's caressing grip
Earth and all her oceans slip,
Capes of China slide away
From her fingers into day... cb

DONNE's 'A NOCTURNAL upon St Lucy's Day' reminds me of an autumn visit to the Dulwich Picture Gallery, where I saw the exhibition *Whistler and the Thames*. James Abbott McNeill Whistler caused a furore in London when he sued Ruskin for libel. The trial is a precise point in history where a new form of art was firmly established.

The scandal focused on a *Nocturne*, a particular painting by Whistler. Frederick Leyland, an amateur pianist and patron of Whistler's, first suggested the term 'nocturne' to describe Whistler's dark, moody twilight scenes of the Thames River. The word comes from musical terminology, and it is thought that Leyland specifically referred to one of Frederic Frédéric Chopin's *nocturnes*, composed in the 1830s. Whistler took it up with enthusiasm, and would name many paintings *Nocturne in...* (*Blue and Gold, Gray and Gold, Pink and Grey*, etc. It is interesting to note the spelling in the latter two – Whistler was an American expat painting in London.) The use of the word came full circle when, inspired by Whistler's paintings, pianist Achille-Claude Debussy composed his own orchestral nocturnes in the 1890s.

The French word 'nocturne' comes from the Latin for 'night', and is originally a religious term: one of the Offices of prayer around midnight. Donne's poem, written some-

time in the early 17th century, would have drawn upon the religious connotations of the word. The themes are intertwined: like the poem, Whistler's work is dark and muted. During the trial, as he defended his work, Whistler declared that 'a nocturne is an arrangement of line, form and colour first.'[cc] He insisted that he wanted to remove any narrative, 'any outside anecdotal interest,' by washing layers of thin, almost watercolour-transparent oil paint into a hazy, moonlit scene.

Though this style of painting does not startle us now, the technique was met with derision and outrage. When Whistler displayed *Nocturne: Blue and Gold: Old Battersea Bridge*, Ruskin 'accused Whistler of throwing a pot of paint in the public's face,'[cd] and Whistler sued him for libel. Though Whistler won the case, it bankrupted him. But Whistler's descriptive defence of his work, along with his paintings, went down in history.

'I did not intend to paint a portrait of the bridge,' he explained, 'but only a painting of a moonlight scene ... my whole scheme was only to bring about a certain harmony of colour.'[ce]

I'm interested in this distinction, which reminds me of earlier conversations I've had with painters about whether or not they are painting something concrete, or abstract: a portrait, or a picture? A vase, or the idea of a vase? His painting, Whistler claimed, was not a *portrait* of the bridge. His effort to subdue narrative is achieved through the muted, shadowy figures. The bridge is like a Colossus or Grecian column, towering, powerful, anchoring the painting like the trunk of a tree, yet soft enough not to overwhelm the rest of the picture. It breaks the canvas into sections. Only after seeing the bridge and the small, bent, gondolier-like figure on a boat in the foreground, do I notice the shuffling, quiet figures crossing the bridge above. It is quietly dynamic, achieving the mysterious hush of people going about their business at night. The blue tones make the river scene feel not under wa-

ter, but *of* the water, with a gentle glow of light from boats and houses in the distance, and a smattering, Hogarthian 'S' of stars that may be the Milky Way in the sky overhead.

The *Nocturnes* were heavily influenced by Whistler's admiration of Japanese art, and this painting has been described as 'a combination of East and West – a Japanese influence and a Western subject.'[cf] It is true that the fine lines, of both the figure on the boat and the fog-cloaked masts of ships in the distance, have an Asian delicacy, like calligraphy. Whistler's nocturne is a meditation on mood and atmosphere rather than subject matter. This may be Old Battersea Bridge, but it could also be anywhere in the world, anywhere in time.

Chapter Twenty-Five

When you are old and grey and full of sleep,
And nodding by the fire, take down this book,
And slowly read, and dream of the soft look
Your eyes had once, and of their shadows deep;

How many loved your moments of glad grace,
And loved your beauty with love false or true,
But one man loved the pilgrim soul in you,
And loved the sorrows of your changing face ⋈

THE FIRST PIECE of real art – not a print or postcard – that I have ever bought, I found at the end of my month in Bruges. On the last few days of class, our lunch breaks stretch longer, as do Bill's lunchtime naps. The sun shines more often. Sometimes I go to lunch with the three people who spend the afternoon painting me, and we all agree to return late together. Sometimes I come in from the lunch break to find none of the painters in the studio. These relaxed afternoons allow me to discover a gallery I've cycled past almost every day. I'd often stopped outside its large window to marvel at the paintings. They are all miniature oil paintings: portraits; still life arrangements; reproductions of famous Dutch ship scenes. Finally, one afternoon, I pass the gallery when it is open, ring the bell, and venture inside. A petite, friendly woman with funky spectacles and cropped hair greets me in French. I manage to explain that I'm interested in her gallery because I'm modelling for an oil painting class in the Old Master's style – just like her work. Thrilled, she insists that I bring Bill to meet her.

I catch him on his way into the studio, and he decides that we should make it into field trip with the three students who are meant to paint me that afternoon. He can tell that even my patience for repetition is beginning to wane, and I think his is, too. Everything about the class has the feeling of coming to a close. We walk around the corner to the gallery, and there is an enthusiastic exchange of compliments and ideas, which I do my best to translate, as the gallery owner, who has no English, and I, are the only ones in the party to speak French. Bill is extremely impressed with her work, and if he says it's good, I trust it. The paintings are done on wood, and the artist, whose name is Madame Zouaoui, explains the long process of preparing the boards and painting many layers over each piece to get the effect. It can take three years for her to complete a painting. She works on many, in rotation, at any given time.

I've wanted to buy one of the miniatures since seeing them through the gallery window, and Bill's confirmation of Madame Zouaoui's skill and fair prices decides me. I consider two miniatures. Bill sits next to me.

'Take your time. It's important that the decision feels right to you.'

I finally choose, make my arrangements, and after I'm paid my wages for the week, am very pleased to cycle back and exchange cash for the miniature. It feels right that art should support art.

My painting is about two inches by three inches in size. The scene is delicate, tiny, clear: a calm ocean with three ships and a large sky. The wind is quiet; the sails are slack, the water still, reflecting the hulls of the boats. A few white gulls wheel overhead; two more sailing vessels are visible in the distance. The clouds flicker with varied light and shadow, but float through a blue, bright sky. It is peaceful. There is a small patch of land in the foreground, indicating the viewer's perspective, looking out to sea from the shore. A sea view is one of my favourites, wherever I am in the

world. Living in London means I'm not as near as I wish to the ocean, but this painting, when I eventually hang it on my bedroom wall, brings it closer.

Back in London after my month in Bruges, I make a pilgrimage to the Wallace Collection. Bill and Sandra are stopping in London on their way home to the States and we've arranged to meet there so Bill can, as he puts it, 'introduce me to myself': the Velázquez portrait, *The Lady with a Fan*.

The painting is smaller than I expected; the idea of things is so often more grand than their reality. I peer at the portrait, thinking of my time in Bruges. How long did Velázquez ask her to sit? Did her back ache? Was her stomach grumbling? Or was it like so many works done for wealthy patrons, where a paid model sat for everything but the face? How many women actually sat for this portrait? If several, then the girl equivalent to me would be not the subject, but the commoner, draped in fine dresses and jewellery she'd never be able to afford. I think of the Prada dress I once wore in the Chelsea studio.

This lady's ruffled gloves, lacquered fan, and necklace of jet are modest but sumptuous. She displays a golden rosary. I think of how, for the portrait in Bruges, I ended up draped in a pink silk robe, more covered than any of us had anticipated, but showing far more flesh than this. Yet her cleavage is presented in a style with which I am rarely comfortable, reinforcing my thoughts on the contradictions of modesty.

She is both beautiful and demure, making one want to look more closely, yet remain at a distance. She seems straightforward, as if she wouldn't have hesitated to tell Velázquez exactly what she thought of the finished work. Sometimes, when I consider her expression, I think she looks peaceful. Sometimes, I see a touch of sadness in her gaze. Perhaps what I like best of all is that no one knows for certain who she is.

Acknowledgements

This book would not have been possible without the support of William Whitaker and his students at the Atelier; Daniele Iozzia; Nicola Pappalettera; Joel and Rob Wareing, and the teachers and students of art classes throughout London.

I am delighted that Jamie McGarry of Valley Press wanted to publish this book, and I am indebted to him for editorial and design skills. For improving editorial comments, I am very grateful to Richard Skinner and Henrike Scholten. Any errors are entirely my own.

For the joyful encouragement to pursue subjects that spark my imagination, my dear friends and family have my eternal love and thanks.

Endnotes

a Emily Dickinson poem 1015.
b 'The Lady of Shalott,' Alfred, Lord Tennyson, 1842.
c Christina Rossetti, 'Goblin Market'.
d Spenser, *Prothalamion*.
e 'The High Art of the Low Countries,' BBC Four, 9 April 2013.
f Oscar Wilde, *The Picture of Dorian Gray*.
g Thomas Fuchs, 'The Phenomenology of Shame, Guilt and the Body in Body Dysmorphic Disorder and Depression.' Journal of Phenomenological Psychology, 33:2. 2003.
h Barthes, Roland. *Camera Lucida: Reflections on Photography*. Translated by Richard Howard, Flamingo. Fontana Paperbacks, London, 1984. p.45.
i Warner, Marina, *Phantasmagoria*, p.36.
j Marilyn Monroe.
k The Works of the late Edward Dayes: *Essays on Painting*. London, printed by T. Maiden, Sherbourn-Lane, Lombard-Street, 1805. p.213.
l Ibid. 216.
m Deborah Davis, *Strapless*. Penguin, 2003. Sutton Publishing Limited, 2004. p.42.
n *The Poetical Works of Alexander Pope, Esq*. London, published by Jones and Co, July 3 1824.
o Martha Graham.
p John Keats, 'If by dull rhymes our English must be chain'd'.
q Virginia Woolf: *A Haunted House: The Complete Shorter Fiction*, Vintage Books, London, 2003, p.77.

r Original text, *Fanny Hill*, p58, Bookakke edition.
s Alexander Pope, 'The Rape of the Lock'.
t Oscar Niemeyer, *Architectural Record*, 1997.
u Marina Warner takes this 'repeated and unexamined hearsay' to task in Chapter 15 of *Phantasmagoria*.
v http://www.bbc.co.uk/news/world-latin-america-20621265 6 December 2012. 'Oscar Niemeyer, Brazilian architect, dies at 104. BBC News.
w *The Poetical Works of John Milton*, London, Oxford University Press, 1930.
x Hogarth, *Analysis of Beauty*, p.25. (online version, p.45.) http://archiv.ub.uni-heidelberg.de/artdok/volltexte/2010/1217/pdf/Davis_Fontes52.pdf
y Clark, *The Nude*, p.133.
z Hogarth, *Analysis of Beauty*, 'Of Lines' p.52-53 online copy http://archiv.ub.uni-heidelberg.de/artdok/volltexte/2010/1217/pdf/Davis_Fontes52.pdf

aa Hogarth (ibid).
ab Gustave Flaubert, *Madame Bovary*, trans. Lydia Davis.
ac Roland Barthes, *Camera Ludida: Reflections on Photography*. Translated by Richard Howard, Flamingo: Fontana Paperbacks, London, 1984. p.13.
ad Dayes, Edward: *Essays on Painting*. London, printed by T. Maiden, 1805. Emphasis original.
ae Charles Darwin, *The Expression of the Emotions in Man and Animals*.
af Richard Lovelace, 'To Althea, from Prison'.
ag Peter Steinhart, *The Undressed Art: Why We Draw*, Vintage Books, New York, 2005, p.191.
ah Kenneth Clark, *The Nude: A Study of Ideal Art*. John Murray, 1956. p.6.
ai *Turner's Secret Sketches*, Ian Warrell. Tate Publishing, 2012, p.126.
aj Ibid, p.18.
ak Ibid, p.63.

al Ibid, p.45.
am Clark, p.3.
an Clark, p.74.
ao Gerard Manley Hopkins, 'The Windhover.'
ap 'The High Art of the Low Countries,' BBC Four, 9 April 2013.
aq I'm ambivalent about audio guides: I think it is good, perhaps best, for people to approach art through looking, and that audio guides can too narrowly 'guide' opinion and interpretation. However, when it is an historical piece about which I know little or nothing, I'm interested to hear what they have to say, and try to draw my own conclusions on top of that information. It's also sad but true that nowadays it is sometimes quieter to be 'plugged in' to your own set of headphones than to go around a crowded gallery without any, as I found in the overcrowded *Manet* exhibition.
ar The High Art of the Low Countries,' BBC Four, 9 April 2013.
as Smith, Greg: *Thomas Girtin: The Art of Watercolour*, Tate Publishing, 2002.
at Dayes, Edward, *Essays on Painting*. T. Maiden, 1805.
au Smith, Greg: *Thomas Girtin: The Art of Watercolour*, Tate Publishing, 2002.
av Ibid.
aw Ibid.
ax Ibid.
ay William Golding, *Lord of the Flies.*
az Gilles Néret, *Reubens*, Taschen, 2004.

ba Ambrose Bierce, *The Unabridged Devil's Dictionary.*
bb www.naturalpigments.com, an extraordinary resource, recommended by Bill.
bc Goethe, *Faust.*
bd 'Visualising the Disabled Body,' Lennard J. Davis, from *The Body: A Reader*, Routledge, 2005.

be 'The Finest Consumer Object: The Body', J. Baudrillard, from *The Body: A Reader*, Routledge, 2005.
bf Paintings in the Musee d'Orsay, New York: Stewart, Tabori and Chang.
bg Warner, ibid. p.49-50.
bh Ibid, p.50.
bi Crawford, Joseph. "Fetter'd, in spite of pained loveliness': formal restraints and Gothic fictions," p.18. *The Rules of Form: Sonnets and Slide Rules*, Ed. K Swain, Whipple Museum of the History of Science, 2012.
bj Ibid.
bk Rainer Maria Rilke, 'Archaic Torso of Apollo' (trans. Stephen Mitchell).
bl Steinhart, *The Undressed Art*, p.100.
bm *The Undressed Art*, p.189.
bn Virginia Woolf, *Orlando*.
bo Clark, p.65.
bp Steinhart, p.98.
bq 'The Big Sleep'. The Independent, Saturday 9 September 1995.
br Clark, p.84-5.
bs 'The Naked Truth,' V R Main, The Guardian, 3/10/08.
bt *Manet* by Alan Krell, Thames & Hudson, p.49-50.
bu *A Woman with No Clothes On*, V R Main, Delancey Press.
bv 'The Naked Truth,' V R Main, The Guardian, 3/10/08.
bw *Manet: Portraying Life*: Royal Academy of Arts exhibition catalogue, 2013.
bx D.H. Lawrence, 'Elemental'.
by 'Lucky Hunter-Gatherers' by T.J. Clark, London Review of Books, 21 March 2013.
bz Clark, *The Nude*, p.80-81.

ca John Donne, 'A Nocturnal upon St. Lucy's Day'.
cb WH Auden, 'Nocturne'.
cc Richard Dorment and Margaret F. MacDonald, *James McNeill Whistler*. Tate Gallery, London. 1994, p.122.

cd Dulwich Picture Gallery, 2013.
ce Dorment and MacDonald, p.131.
cf Dulwich Picture Gallery, 2013.
cg William Butler Yeats, 'When You Are Old'.